The Bahamas

Portrait of an Archipelago

Photographs by Michael A Toogood

With commentary by Larry Smith

MACMILLAN
CARIBBEAN

Macmillan Education
Between Towns Road, Oxford OX4 3PP
A division of Macmillan Publishers Limited
Companies and representatives throughout the world

www.macmillan-caribbean.com

ISBN 0 333 94658 8

First published 2004

Designed by Gary Fielder at AC Design
Map by Martin Sanders
Cover design by Gary Fielder at AC Design
Cover photographs by Michael A Toogood

Printed and bound in Thailand

2008 2007 2006 2005 2004
10 9 8 7 6 5 4 3 2 1

Preface

It is almost impossible for anyone to fully appreciate the beauty of The Bahamas through the pages of a book; to experience the brilliance of colour as sea swells break along the coast, cascading into a pearly mist full of the scent of life itself; to savour unseen flowers, teasing the evening air with fragrant hints that let us know that they are not too far away; to enjoy a child's fleeting smile that utters no sound but yet tells all. Only with great effort can these images be captured, even by the most inspired artist.

This book is not intended to be a complete photographic journal of The Bahamas, as only a handful of islands are represented on its pages. There are over 30 major islands in our archipelago, from Grand Bahama in the north to Inagua in the south, from Bimini in the west to Mayaguana in the east. Each is unique in its own way. Each has its own character, its own soul and its own story to tell. But, as are links in a golden chain, each is as important as the whole. *The Bahamas: Portrait of an Archipelago* attempts to open a window on The Bahamas; to take a peek at a nation as colourful as its past; to offer a personal introduction to a warm and welcoming people and the beauty that surrounds them. It is hoped that this book will help you to look beyond the window and begin to explore and enjoy all that these islands have to offer.

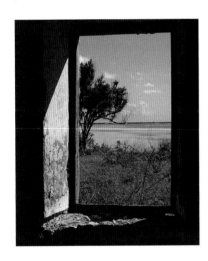

It would not have been possible to complete this book without the assistance (and sometimes the insistence) of Larry Smith, Neil Sealey and my wife, Tracy. Also it would be remiss if I did not thank Captain Paul Harding for those seven minutes of 'open window' time; Freddie Farrington for the use of his house in Current, Eleuthera; and George Johnson, proprietor of the Hallover Inn on Cat Island, for the use of his truck.

Also thanks to Governor-General Dame Ivy Dumont DCMG; Dr Gail Saunders, OBE, Director of National Archives; Paul Thompson, Lyford Cay; Sandra Eneas, Atlantis Resort; and Ray Cass and his staff at Mr Photo.

This book is dedicated to the memory of my parents and brother. And when my son, James, grows up I hope he will treasure the beauty of these islands through the pages of this book.

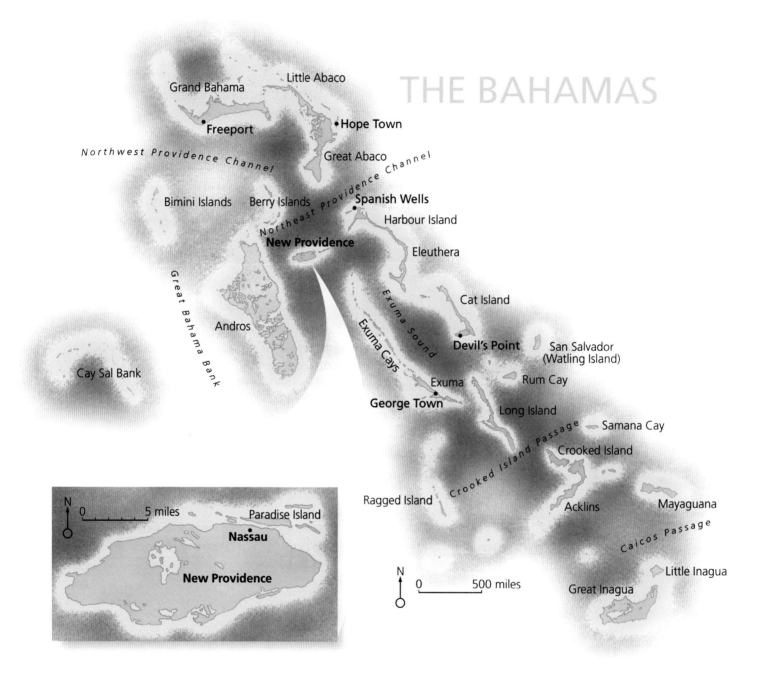

THE BAHAMAS

Little Abaco

Grand Bahama

• Freeport • Hope Town

Northwest Providence Channel

Great Abaco

Bimini Islands Berry Islands **Spanish Wells**

Northeast Providence Channel

Harbour Island

New Providence

Eleuthera

Great Bahama Bank

Cat Island

Andros

Exuma Sound

Devil's Point San Salvador
(Watling Island)

Exuma Cays

Cay Sal Bank

Exuma Rum Cay

George Town

Long Island

Samana Cay

Crooked Island Passage

Crooked Island

Ragged Island

Acklins Mayaguana

Caicos Passage

N

0 5 miles Paradise Island

Nassau

New Providence

N

0 500 miles Little Inagua

Great Inagua

iv

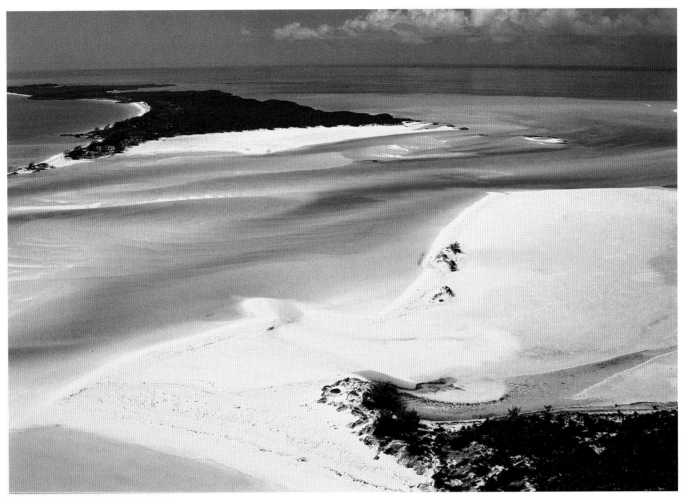

Set between the oceanic depths of Exuma Sound and the sandy shallows of the Great Bahama Bank is a 140-mile chain of islets whose spectacular beauty is world-renowned. Over 170 square miles of the Exuma chain were set aside in 1959 as the world's first land and sea national park. Managed by the Bahamas National Trust, a statutory non-governmental conservation organisation, the Exuma Cays Land and Sea Park is the first and largest no-take marine reserve in the wider Caribbean and a model for marine conservation efforts around the world. This aerial shot of the Exumas displays the characteristic Bahamian topography – small low-lying islands rising from sandy banks beneath a multi-hued sea stretching to a deep ocean drop-off.

Islands of the Shallow Sea

'The Bahama Islands … are the creations of prehistoric winds, the tops of Pleistocene sand dunes. We cling to the land like shipwrecked sailors, our horizons terrestrial. However, The Bahamas are fundamentally a marine wilderness.' (David Campbell, *The Ephemeral Islands*)

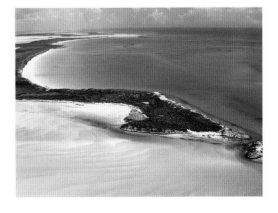

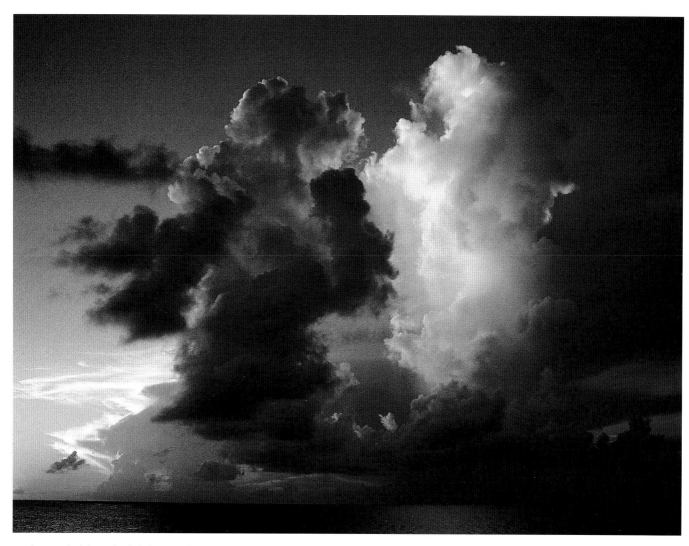

As they settled down in their hammocks, caressed by the steady easterly breezes, the Lucayans of Guanahani would never have imagined that with the dawn would come the end of an era and yet at the same time the beginning of a new world.

Although its total land area is greater than the island of Jamaica, the Bahamian archipelago is strewn over more than 100,000 square miles of ocean between Florida and Hispaniola, with hundreds of small islets and cays – the peaks of ancient dunes – divided by wide sandy plateaux (or banks) and deep oceanic canyons.

This fractured geography, so proximate to the American mainland and astride both the Atlantic and the Caribbean, has influenced the country's history ever since the days when Amerindian tribesmen paddled island-hopping canoes from South America. The very name 'Bahamas' derives from the Spanish words for shallow sea: *baja mar*.

Columbus' Log, October 12, 1492: 'Tierra! Tierra!' Pinta seaman Rodrigo de Triana.

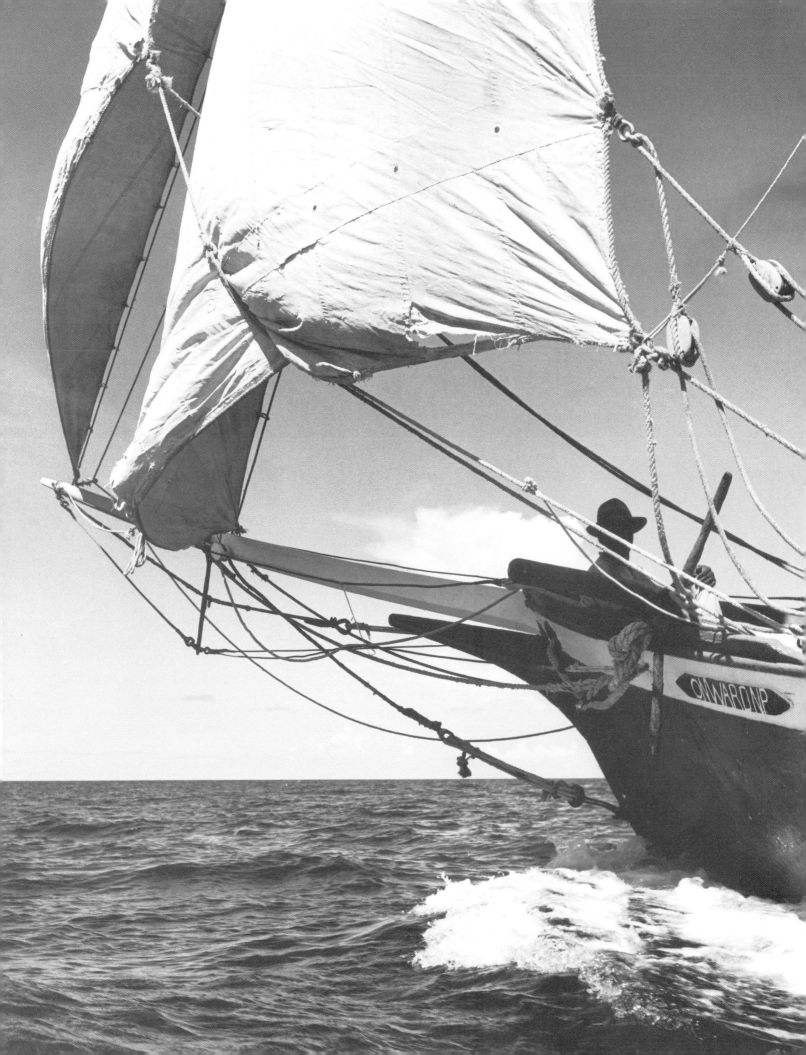

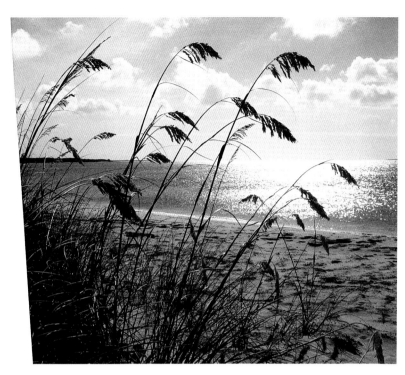

)our in San Salvador, which Columbus described in his log as 'big enough to stendom'.

ɾo

And as it happened, Columbus was almost bound to hit one of these low-lying islands simply by carrying the trade winds across the Atlantic. In fact, the same easy route was used by ships headed to the West Indies for more than four centuries after the great navigator landed on San Salvador in the southern Bahamas, convinced he was in India.

Opposite page

For centuries, trading vessels and those that preyed on them have used the Bahama channels as a preferred route into the northerly flowing Gulf Stream and the Americas or the more sheltered route south to the Caribbean and the West Indies.

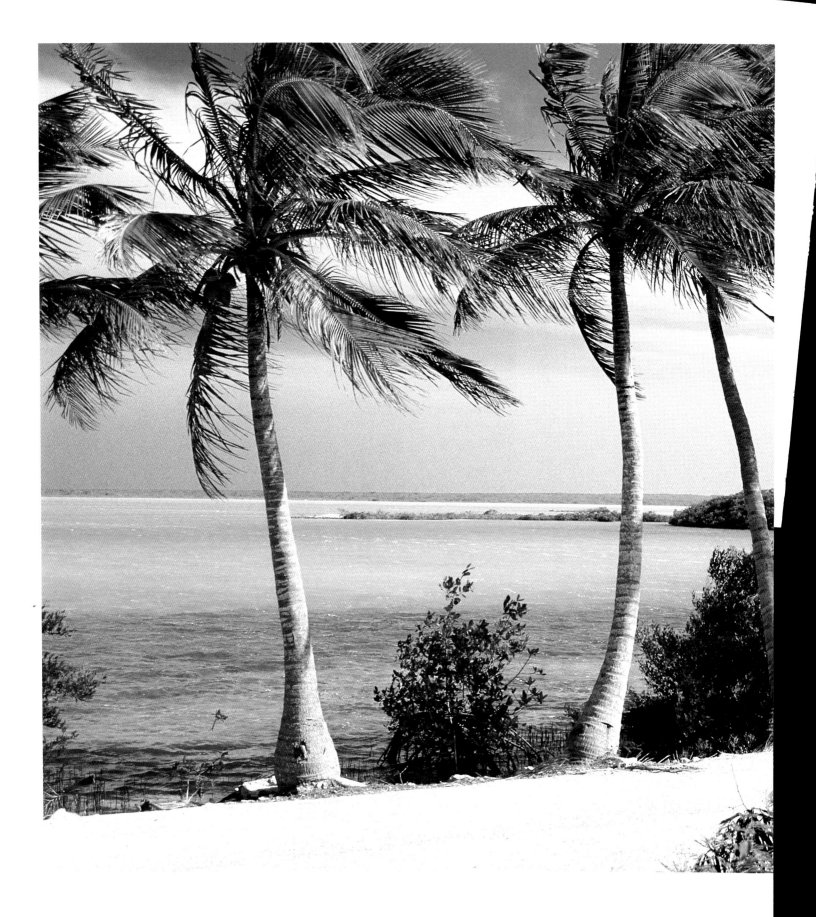

Columbus' first meeting with the Lucayan 'Indians' who occupied the Bahamian archipelago in 1492 was almost idyllic: 'This afternoon the people came swimming to our ships, and in boats made from one log. They brought us parrots, balls of cotton thread, spears, and many other things.' (Columbus' Log, October 12, 1492. Translation by Robert Fuson)

A view of Pigeon Creek on the eastern shore of San Salvador, the site of a major Lucayan Indian settlement which has been under archaeological investigation for years.

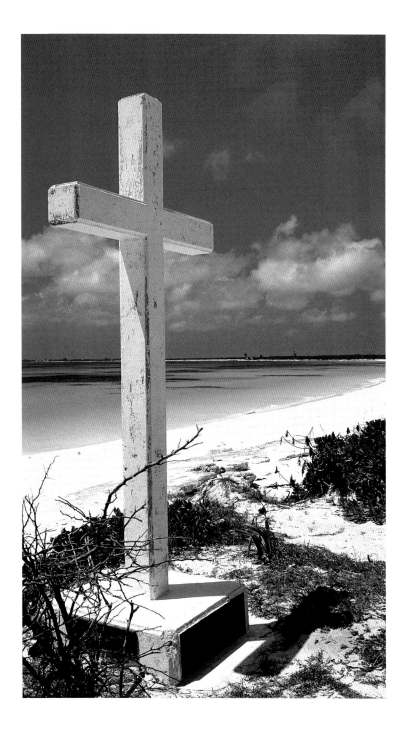

Long Bay on the island of San Salvador in the southern Bahamas is the generally accepted site of Christopher Columbus' historic landfall in the New World. This simple white cross on the landfall beach provided the setting for ceremonies marking the 500th anniversary of the landfall in 1992. A few years earlier, in 1983, archaeologists digging nearby discovered 15th-century Spanish and Lucayan artefacts (including glass beads, buckles, coins and pottery) in close proximity to each other. Several other archaeological sites have been identified around the island. San Salvador supported large farming estates in the 18th and 19th centuries and American military bases in the years following World War II. Today it is home to international students at the Bahamian Field Station and international tourists at the Club Méditerranée resort village.

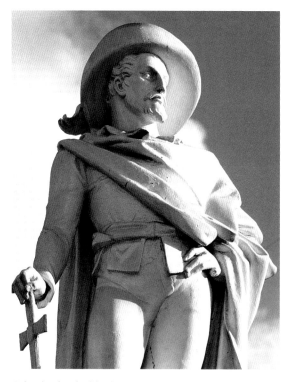

Columbus' arrival in the New World was long celebrated as Discovery Day in The Bahamas, but modern political correctness has eroded this designation. It is now known as National Heroes Day. The familiar statue of the great navigator on the steps of Nassau's Government House was modelled in London by the American writer and diplomat, Washington Irving, who wrote a biography of Columbus in 1828. The statue was brought to Nassau in 1832 by the British governor, Sir James Carmichael Smyth.

But the momentous encounter inaugurated a terrible new era in human history; a time that witnessed great tragedy and dislocation, but which also led to the creation of new multi-racial and democratic societies – like today's Commonwealth of The Bahamas.

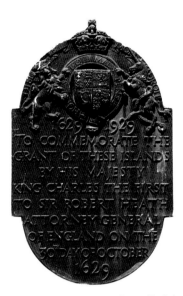

The Spaniards who followed Columbus deported the peaceful Lucayans to servitude in Hispaniola and Cuba, and the islands lay deserted for over a century. Although claimed by the British in 1629, it was not until the mid 1600s that the first permanent European settlement was established on a central island they named Eleuthera (from the Greek word for 'freedom').

This bronze plaque on the wall of the House of Assembly building in Nassau's Rawson Square commemorates the formal British claim to The Bahamas in the form of a 1629 land grant by King Charles I to his attorney-general, Sir Robert Heath. Actual settlement did not take place until 1648.

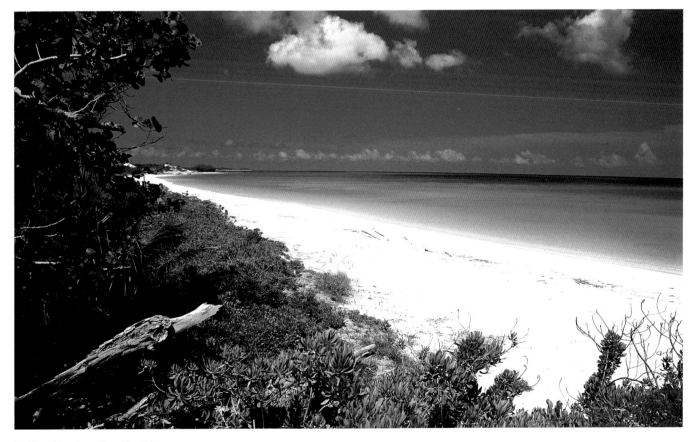

Old Fort Beach on New Providence.

When the first British settlers sailed to The Bahamas from Bermuda, they were shipwrecked off North Eleuthera on treacherous reefs known today as the Devil's Backbone. In this picture, a storm brews over the reefs as a pleasure boat cruises past the skeleton of a more recent wreck.

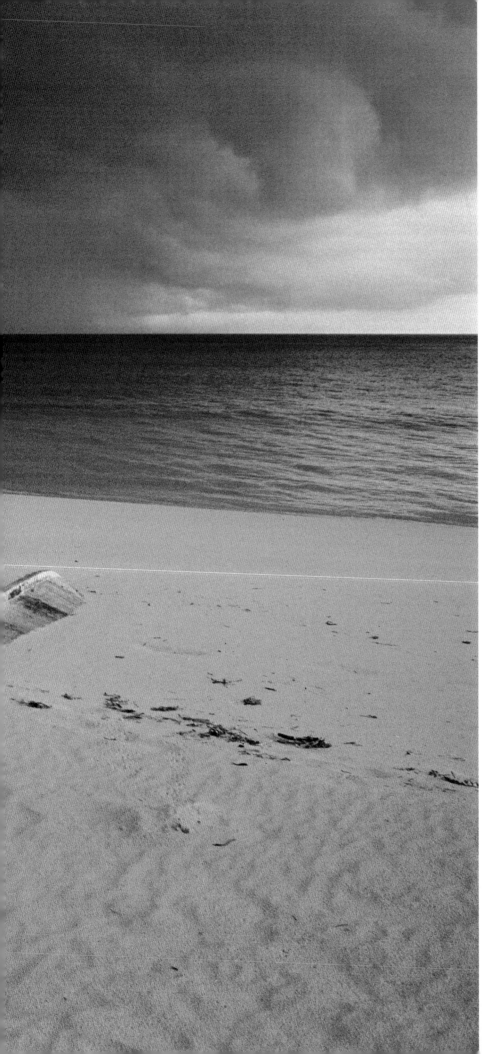

Led by William Sayle, a former governor of Bermuda (settled by the British in 1612), these colonists – expressing the religious and political conflicts of the English Civil War – devised the first republican constitution in the New World. But, much like the early settlements in Virginia, their venture was not successful and they quickly resorted to a subsistence lifestyle relying on salvage and foreign aid for survival.

The Eleutheran Adventurers (as the early British settlers styled themselves), sought shelter and a place of worship in what became known as Preachers Cave, living off 'such fruits and wild creatures as the island afforded', while their leader sailed to Virginia in a small boat to bring relief in what was probably the first instance of American 'foreign aid'. The Bahamians later repaid the debt with goods that helped fund Harvard College.

As more and more people came to the New World, the population in The Bahamas began to swell too. The island of New Providence was settled around 1666, and within five years had over 900 inhabitants. 'By 1670 the total population of The Bahamas was almost 1100, including slaves,' wrote historian Michael Craton. 'But these hardy settlers were without government, protection or law.' (Michael Craton, *History of The Bahamas*)

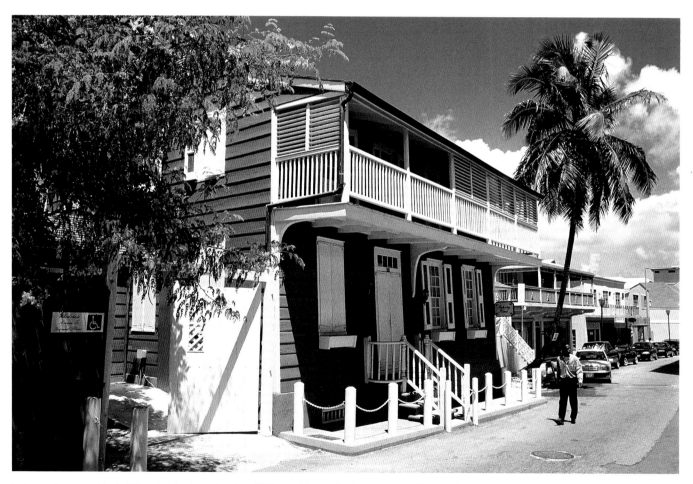

Balcony House on Market Street dates from the late 1700s and is a typical wooden townhouse of early Nassau. It is believed to have been built by a shipwright and is now a museum. In the late 1600s the town of Nassau had only 160 houses, with a church, a market and two bars. Balcony House was once owned by Lord Beaverbrook, the Canadian newspaper magnate who became a British cabinet minister during World War II and spent much time in The Bahamas immediately after the war.

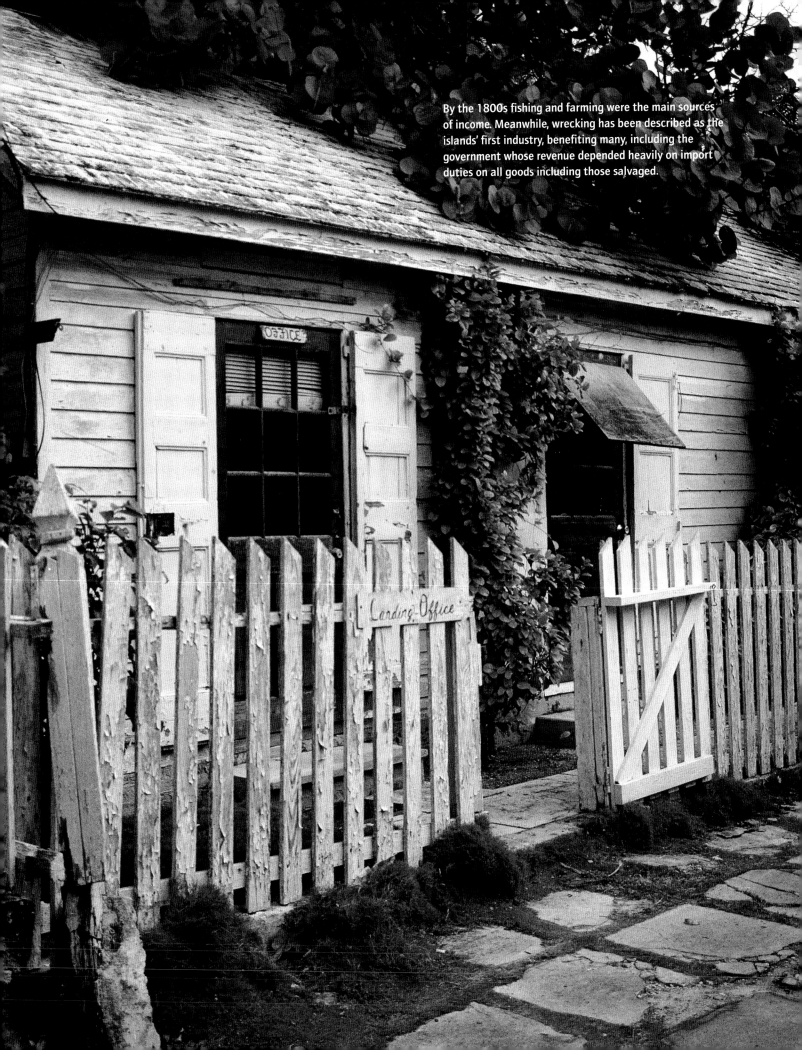

By the 1800s fishing and farming were the main sources of income. Meanwhile, wrecking has been described as the islands' first industry, benefiting many, including the government whose revenue depended heavily on import duties on all goods including those salvaged.

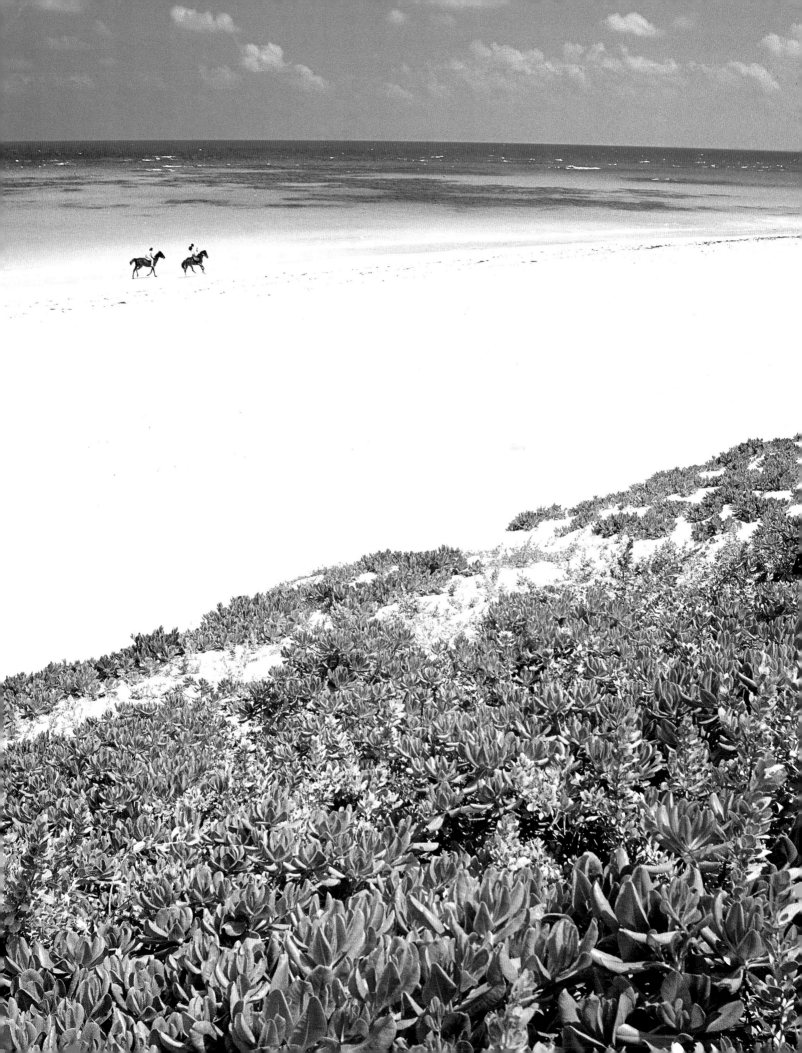

Harbour Island during the 18th century was second only to Nassau in population and prosperity. With its fertile lands and well known ship building industry, it soon became known as the second capital of The Bahamas. Although tourism is now the mainstay of the island, the past successes of its farming and craftsmanship are reflected in the island's character today.

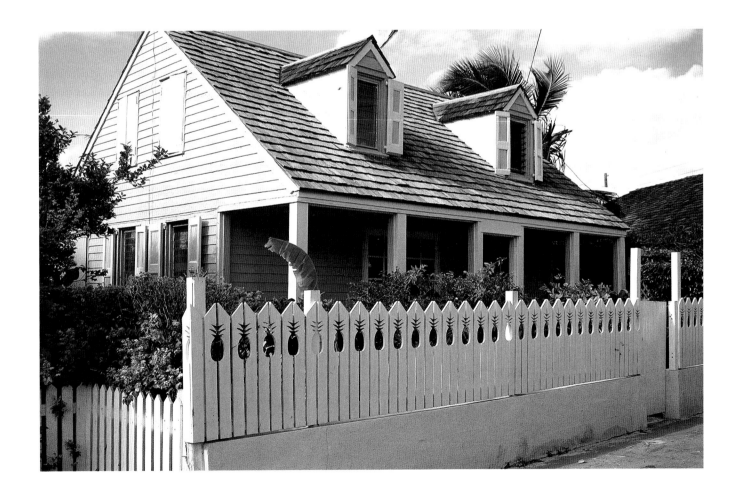

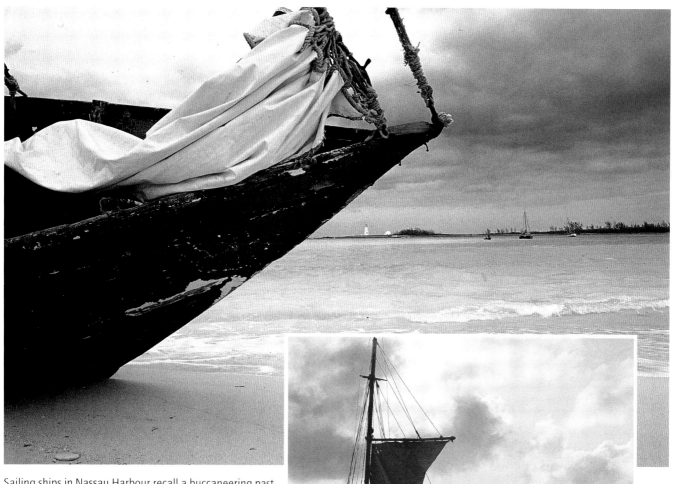

Sailing ships in Nassau Harbour recall a buccaneering past.

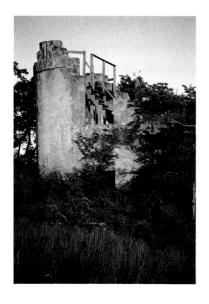

This ruined lookout off the Eastern Road in Nassau was probably built in the 1700s and is popularly known as Blackbeard's Tower, although it is doubtful if the notorious Edward Teach had a hand in its construction. Teach began his pirating career at New Providence in 1713. He died five years later in a battle off the Carolina coast.

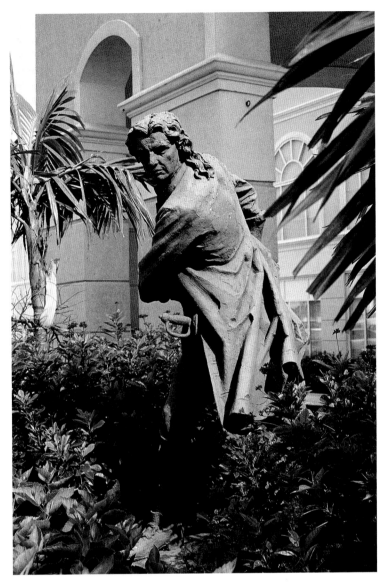

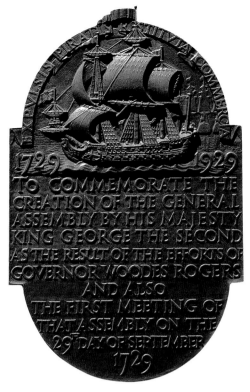

A second bronze plaque in Rawson Square commemorates the island's first representative assembly, called by Governor Rogers in 1729. This parliament has been in continuous existence ever since, although full representation did not occur until the mid 20th century. Slavery was abolished in 1834, but universal adult suffrage and the secret ballot were not achieved in The Bahamas until 1962. One of the new assembly's first tasks was to adopt a national motto – pirates expelled, commerce restored – which lasted until independence from Britain in 1973.

This statue of Woodes Rogers guards the entrance to the British Colonial Hilton in downtown Nassau. Rogers was the man the British chose as governor to restore law and order to The Bahamas. He was also the rescuer of Alexander Selkirk, a Scottish sailor marooned for five years on a desert island in the Pacific. Selkirk's story was later fictionalised by Daniel Defoe in the novel *Robinson Crusoe*. In The Bahamas, Rogers faced down 2,000 pirates, pardoning most and killing those who wouldn't submit. He died in Nassau in 1732.

Increasing population, together with the geographic nature of The Bahamas whose myriad islets and anchorages straddled major commercial sea lanes, made the country a haven for notorious buccaneers. For decades pirates like Blackbeard, Henry Avery, Charles Vane, Anne Bonney and Mary Reade used The Bahamas as a favourite base to raid shipping. Their reign of terror continued until 1718 when Britain's King George I sent troops under Governor Woodes Rogers, himself a former privateer, to make the islands a British Crown Colony.

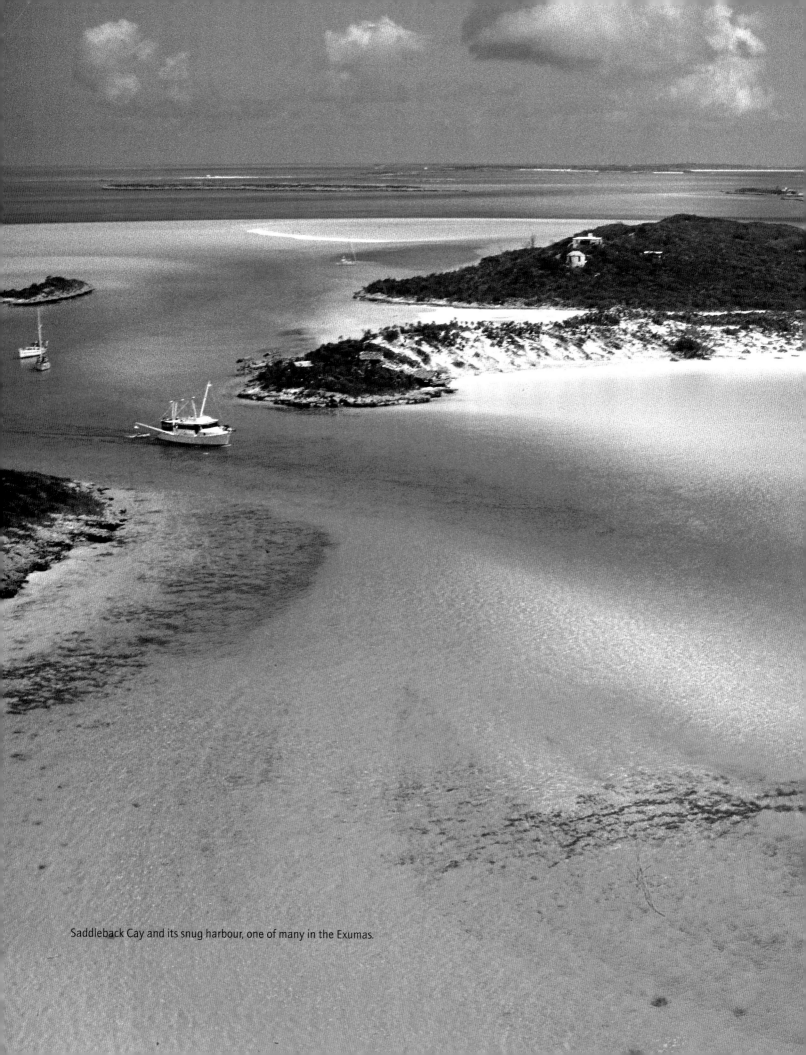

Saddleback Cay and its snug harbour, one of many in the Exumas.

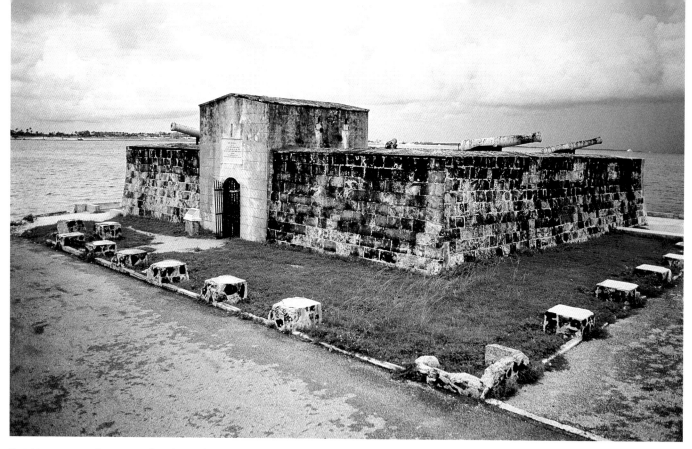

Fort Montagu, on the eastern foreshore of New Providence, was built in 1741 to deter French and Spanish incursions. Named after the Duke of Montagu, who was Master of the King's Ordinance, it was the island's second major fortification (the larger Fort Nassau stood on the site now occupied by the British Colonial Hilton). The fort was captured by the fledgling American navy in 1776. Today, Fort Montagu overlooks a popular beachfront area, although coastal erosion has taken its toll over the years. The now-demolished Montagu Beach Hotel (the country's third hotel) was just a stone's throw from the fort.

Clapboard homes in picturesque settlements on Abaco and Eleuthera are reminiscent of New England maritime villages. Most pro-British refugees went to Canada after the Revolutionary War, but a significant number accepted land grants and positions in The Bahamas.

The strategic considerations that led to the British crackdown were recorded by the 18th-century historian, John Oldmixon, in his *History of the Isle of Providence* (published in 1741). The Bahamas, he said, was 'so necessary for the security of our trade in the West Indies, that the parliament of England have not thought it unworthy of their care, as well to have it cleared of pirates, as to defend it against both Spaniards and French, who find its situation very convenient to annoy or befriend their commerce'.

While the first King George may have saved The Bahamas, his successor of the same name lost far more valuable real estate on the mainland of America. And in fact, the islands played a curious supporting role in the American Revolution as a refuge for thousands of British loyalists and their African slaves driven from the newly-founded United States.

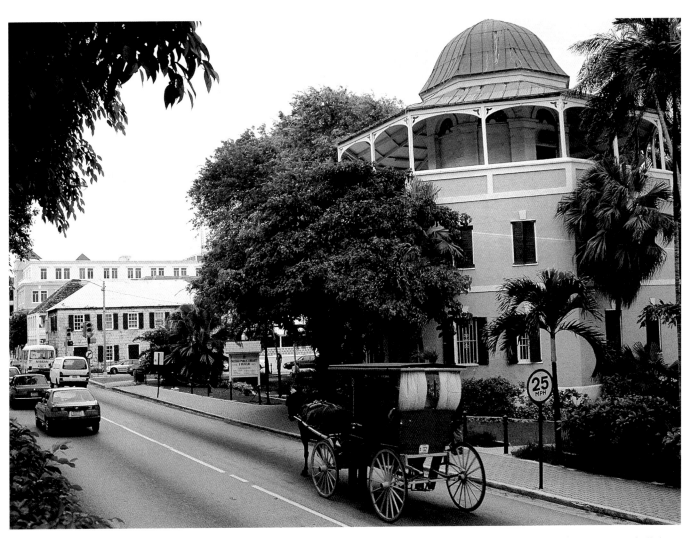

The loyalist migration to The Bahamas resulted in a surge of new public works. The distinctive Nassau Public Library and Museum was built in the 1790s as a jail. Its octagonal design is believed to have been inspired by the Old Powder Magazine at Williamsburg, Virginia. Converted to a library in 1873, it adjoins the War Memorial Gardens, the Law Courts and Parliament Square.

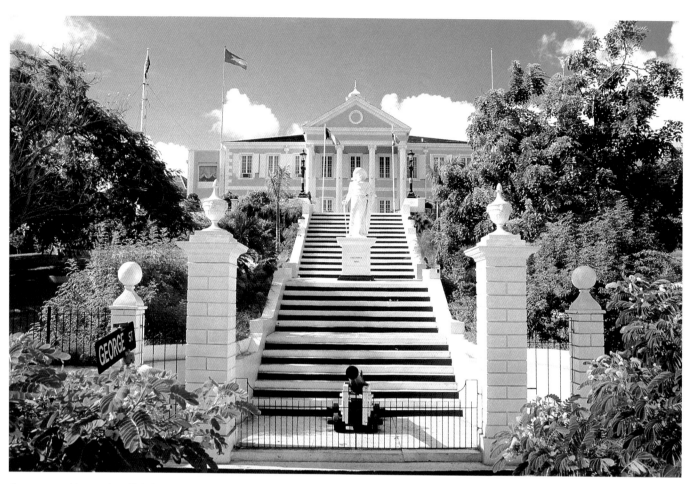

Government House, the official residence of colonial governors and today's governors-general, is built on a rise known as Mount Fitzwilliam overlooking Nassau Harbour. Several residences have occupied the site since Governor Fitzwilliam built a home there in 1737. The building constructed between 1803 and 1806 was partially destroyed by the 1929 hurricane and rebuilt by 1932 much as it is today.

The American War of Independence led to great changes in The Bahamas too. According to Craton, 'In less than five years the population was trebled and the proportion of slaves increased from a half to three-quarters ... The best guess is about 8,000 altogether.'

Loyalists came from places like Florida, New York and the Carolinas to live under the Union Jack. The forced migration ignited a burst of creative energy in the struggling island colony.

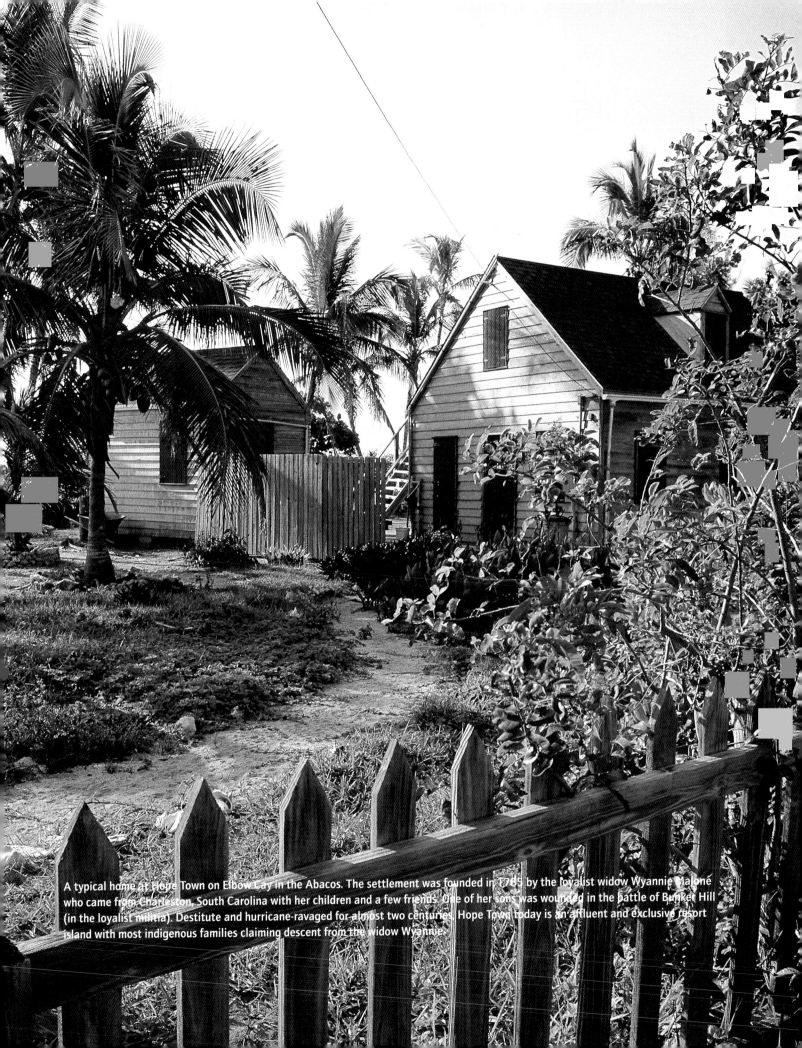

A typical home at Hope Town on Elbow Cay in the Abacos. The settlement was founded in 1785 by the loyalist widow Wyannie Malone who came from Charleston, South Carolina with her children and a few friends. One of her sons was wounded in the battle of Bunker Hill (in the loyalist militia). Destitute and hurricane-ravaged for almost two centuries, Hope Town today is an affluent and exclusive resort island with most indigenous families claiming descent from the widow Wyannie.

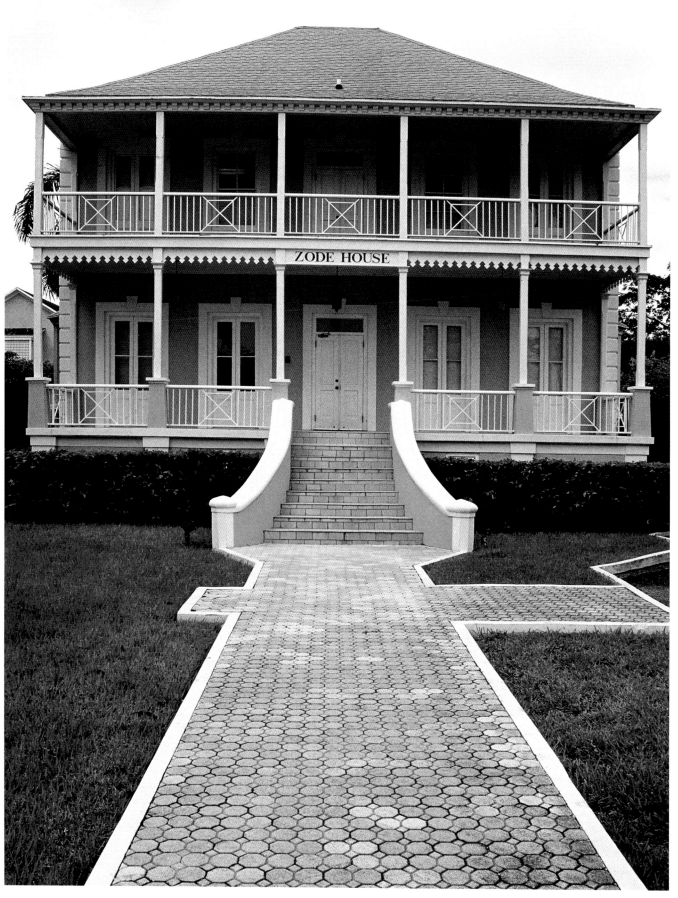

Zode House on Victoria Avenue. Now a law office, this traditional verandahed structure was built as a family home around 1900.

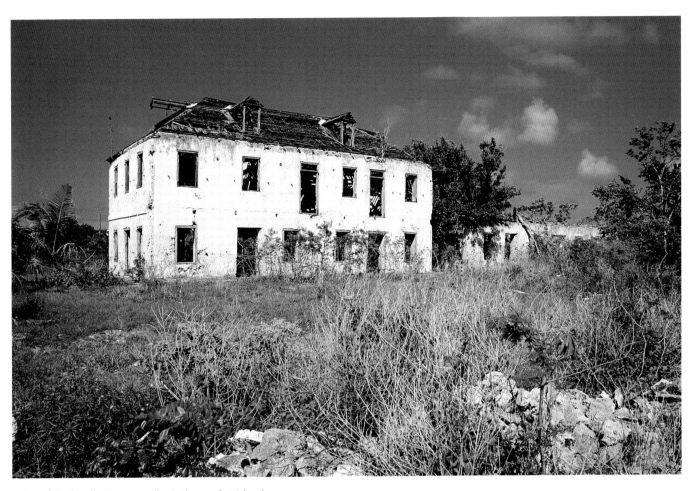

Ruins of the loyalist Deveaux Plantation on Cat Island.

It was during this period that the capital took on the character it has today. As Craton notes, 'the administrative heart of Nassau has changed little since 1815'. This was also the time when other islands in the archipelago were first settled. Since many of the loyalists had been planters on the mainland they were given large land grants throughout the country to set up cotton estates.

After the abandonment of the plantations, many islanders were forced to give up their homes, such as this once splendid seaside home near Tea Bay, Cat Island, in order to find work on more prosperous islands.

Ruins of the loyalist Farquarson Plantation on San Salvador. Before being officially renamed San Salvador in 1925, the island was called Watling Island after a notorious pirate of that name, and these ruins were erroneously known as Watling's Castle.

But by the early 1800s the initial prosperity generated by the loyalist influx had waned. Insect pests and exhaustion of the thin rocky soils led to the abandonment of the plantations, and slavery was abolished by the British in 1834. The islanders turned inwards and resorted once again to scratching a living from wrecking and small-scale fishing and farming.

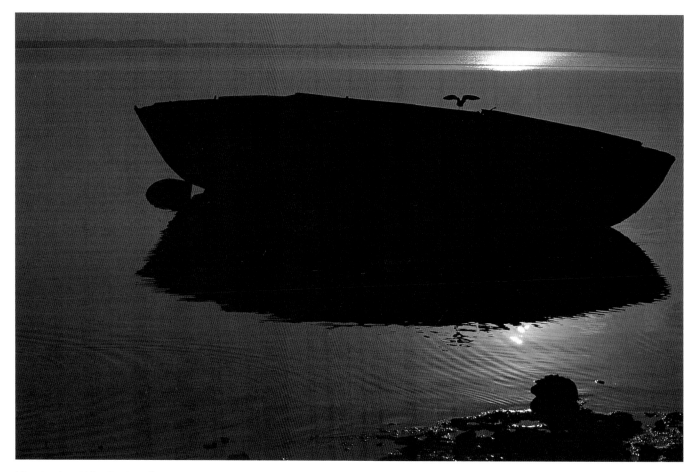

'Wreck ashore! Wreck ashore!'

With the increase in trade between America and the West Indies, it was no wonder that more and more unfortunate mariners were finding their way onto the many reefs that lay along their route, inadvertently or otherwise lured in by the warm and welcoming lights, or lack thereof!

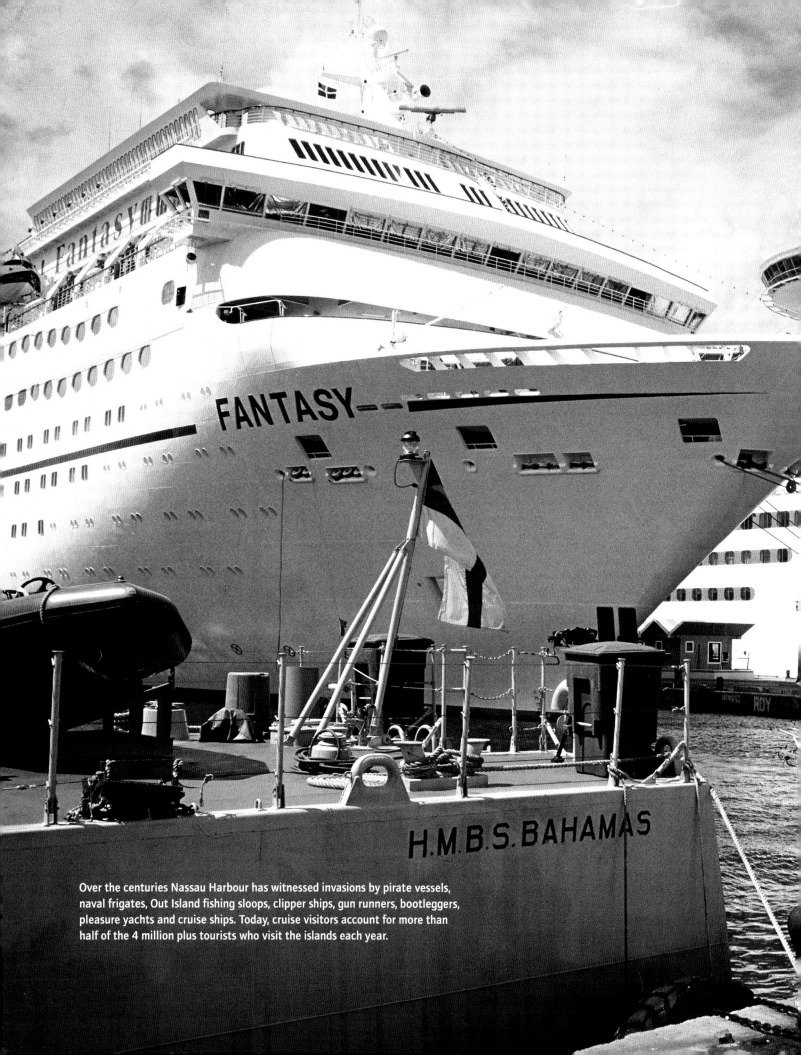

Over the centuries Nassau Harbour has witnessed invasions by pirate vessels, naval frigates, Out Island fishing sloops, clipper ships, gun runners, bootleggers, pleasure yachts and cruise ships. Today, cruise visitors account for more than half of the 4 million plus tourists who visit the islands each year.

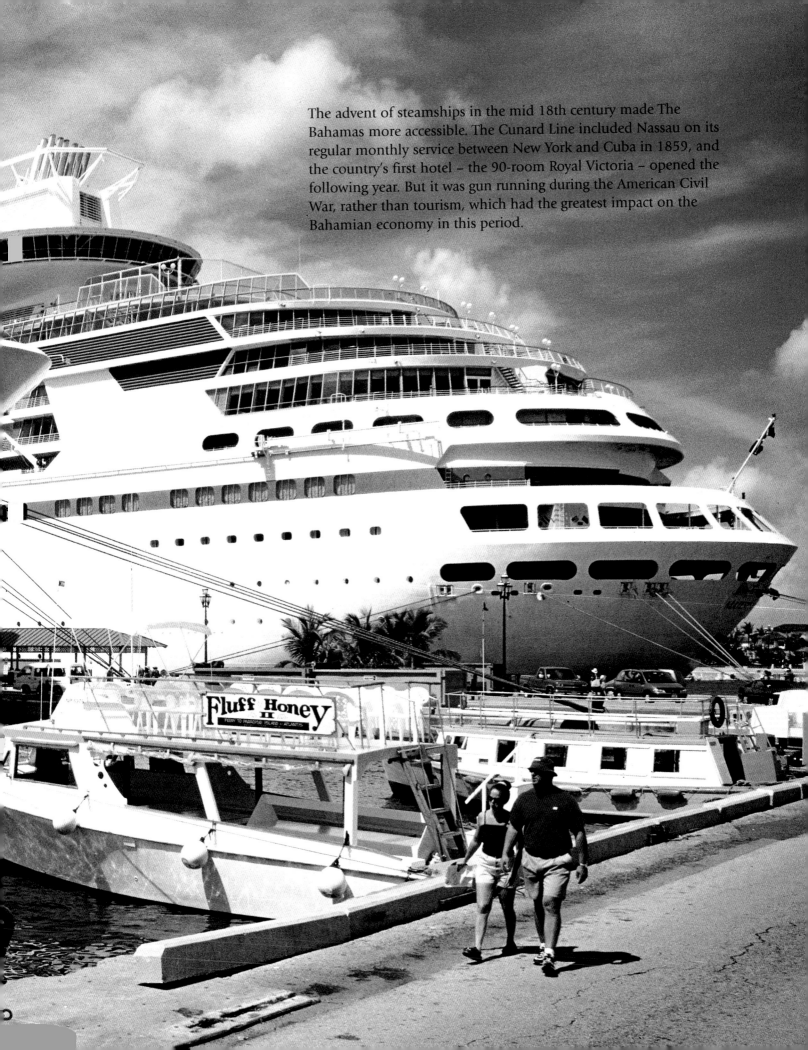

The advent of steamships in the mid 18th century made The Bahamas more accessible. The Cunard Line included Nassau on its regular monthly service between New York and Cuba in 1859, and the country's first hotel – the 90-room Royal Victoria – opened the following year. But it was gun running during the American Civil War, rather than tourism, which had the greatest impact on the Bahamian economy in this period.

By 1862 Nassau was one of the busiest ports in the Americas, with hundreds of steamships and clippers smuggling munitions to Savannah, Charleston or Wilmington in return for cotton to sell on the British market, producing a dramatic economic boom. 'The value of Nassau's trade, which totalled less than £400,000 in 1860, soared to more than £10 million in 1864.' (Michael Craton and Gail Saunders, *Islanders in the Stream*)

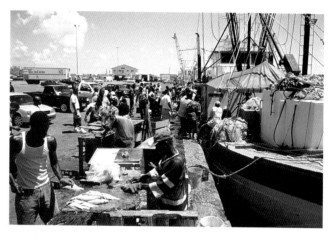

The Market Range in Nassau Harbour is a bustling portside trading area for fishermen, craft vendors, tourists and shopkeepers.

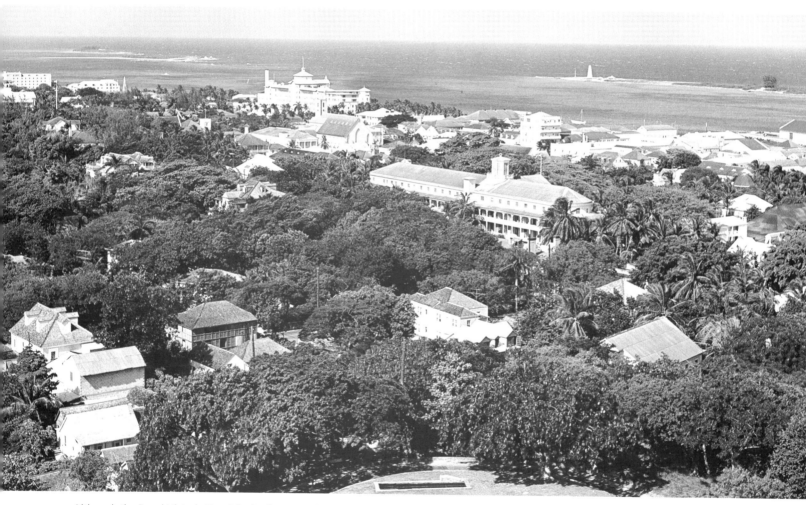

Although the Royal Victoria Hotel, in the foreground, no longer exists, the British Colonial – which at one time was owned by the late Sir Harry Oakes, a Canadian mining millionaire whose mysterious murder during World War II was never solved – has managed to survive for almost a century as a prominent Nassau landmark.

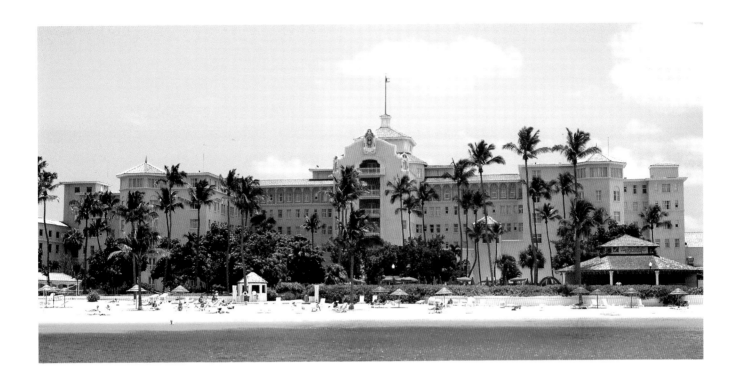

But the economic hangover that followed the war was pronounced. Then, at the turn of the century, Florida pioneer Henry Flaglar signed a steamship contract with the government and bought a prime waterfront site in Nassau to open the country's second hotel – the Old Colonial. (After burning to the ground, this wooden building was replaced by the New Colonial Hotel in 1926. This is essentially the same structure known today as the British Colonial Hilton.)

Idyllic Nassau Beach.

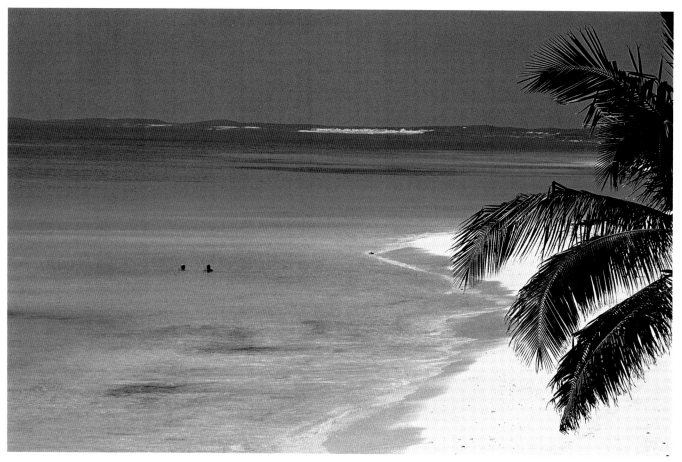

The beach at Hope Town in the Abacos.

The Colonial and Royal Victoria Hotels catered to just a few hundred winter visitors at this time and, in the early years of the 20th century, Nassau was seen as 'an idyllic, almost soporific retreat' while the Out Islands remained even more isolated and remote, reachable only by sailboat. As the Bahamian actor Sydney Poitier recalled in his autobiography: 'There wasn't a paved road on Cat Island. There were no stores ... so my clothes were made out of the cloth of grain sacks ... Thatched-roof houses without plumbing were built largely from materials found around the island. Taxes? There were none. Therefore a family could function year to year having only the slightest amount of cash. No money was needed to build a rock oven.'

A rural road in North Eleuthera.

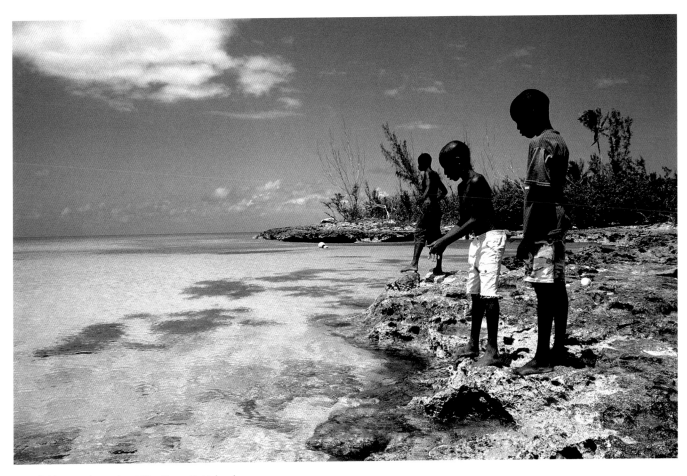

Boys fishing on the rocks at The Cove, Cat Island.

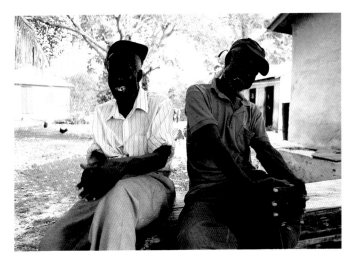

Seasoned villagers on Cat Island. During the past decade, with improvements in infrastructure and the gradual redevelopment of farming and the tourist trade, increasing numbers of islanders have returned to their ancestral homelands.

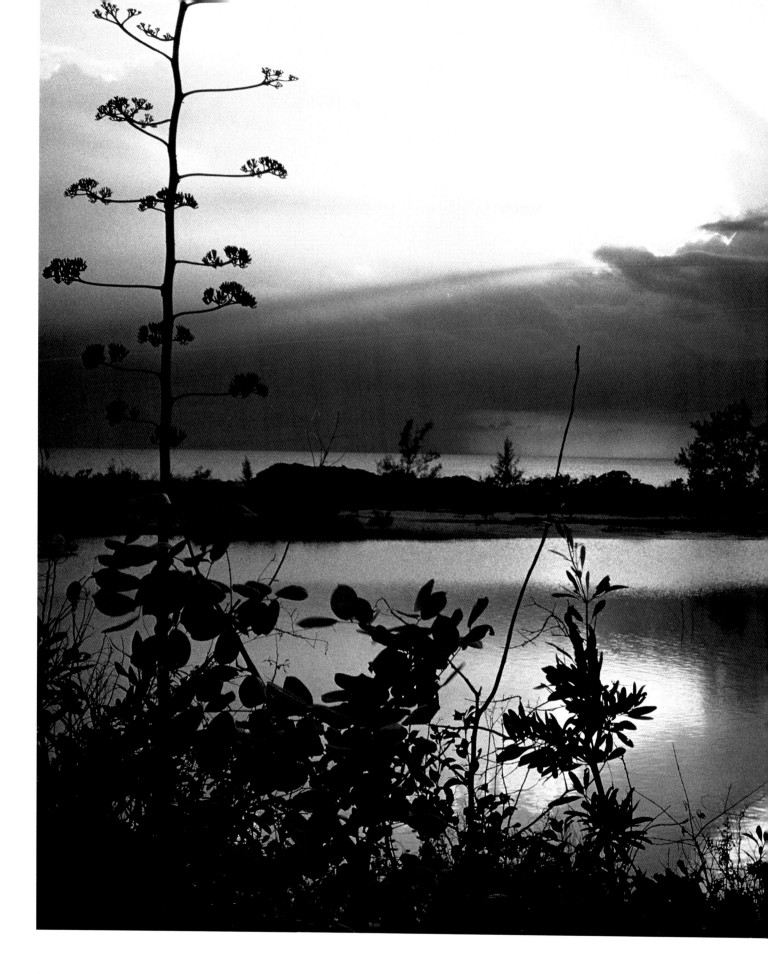

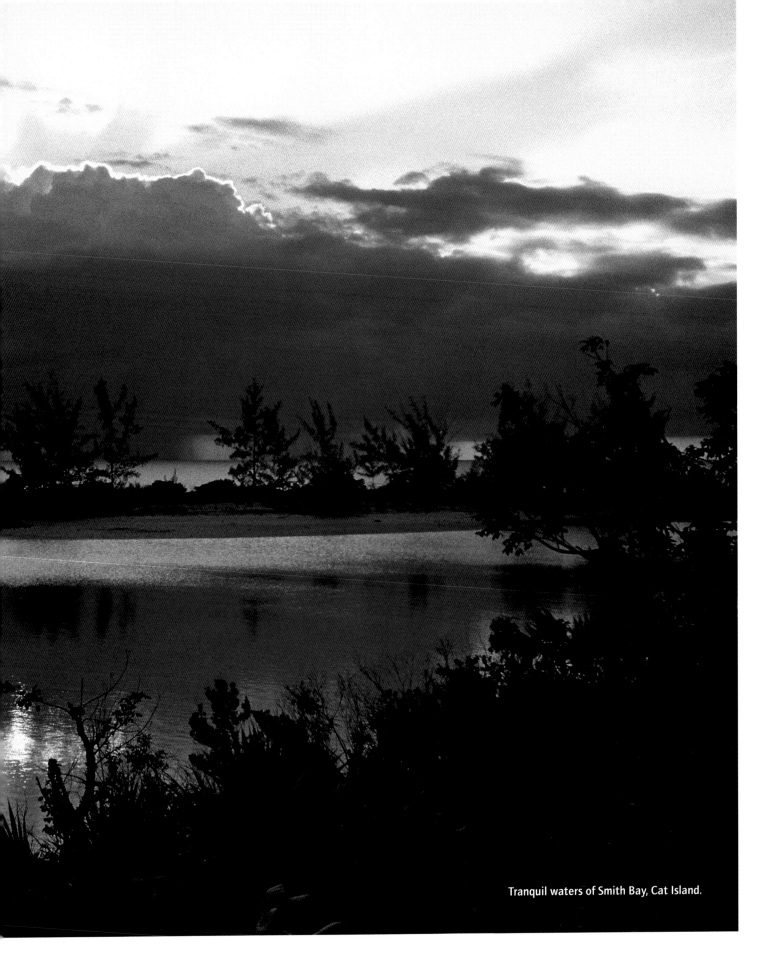

Tranquil waters of Smith Bay, Cat Island.

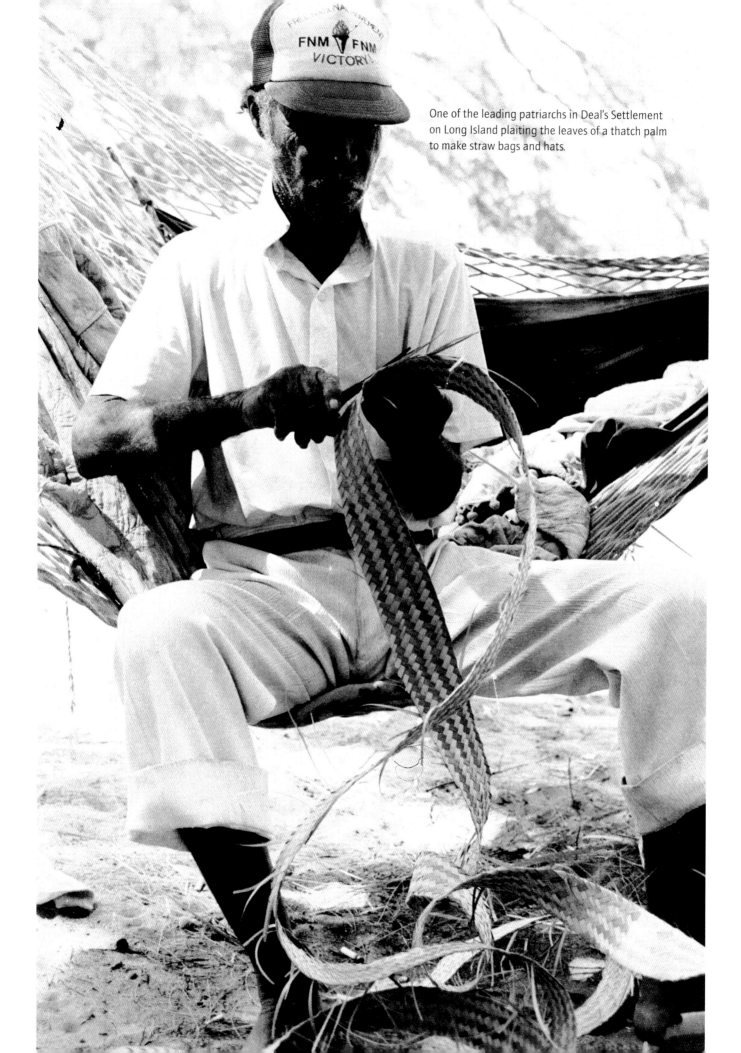

One of the leading patriarchs in Deal's Settlement on Long Island plaiting the leaves of a thatch palm to make straw bags and hats.

This splendid isolation continued until the Prohibition era of the 1920s, with the economy relying on sponge fishing, sisal production and the spending of a handful of affluent winter visitors. But when the United States banned the sale of liquor, the Bahamian capital and islands like Bimini and Grand Bahama came alive with gangs of colourful bootleggers smuggling rum, gin and whisky in fast ships to the American coast – as well as harried FBI agents trying to intercept them.

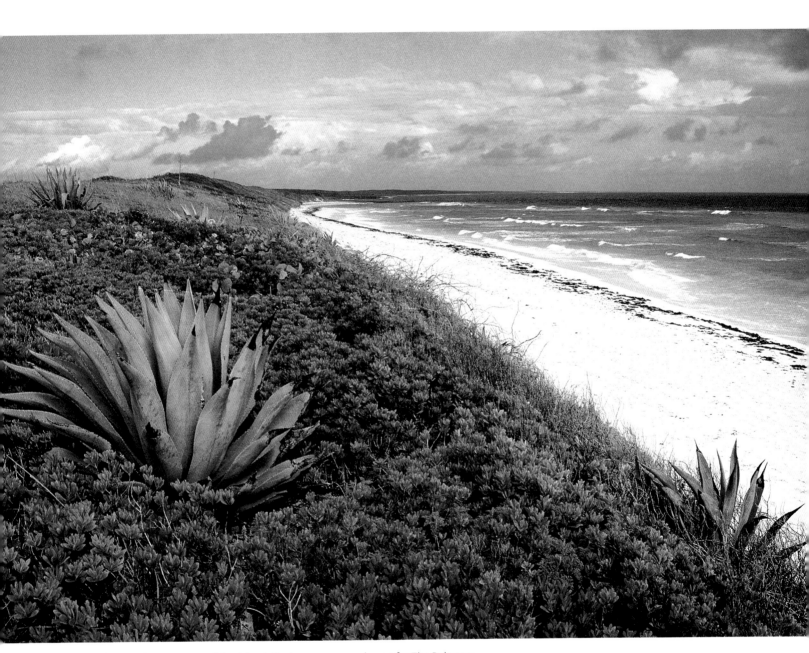

A sisal plant on the east coast of Cat Island. Sisal was once a cash crop for The Bahamas.

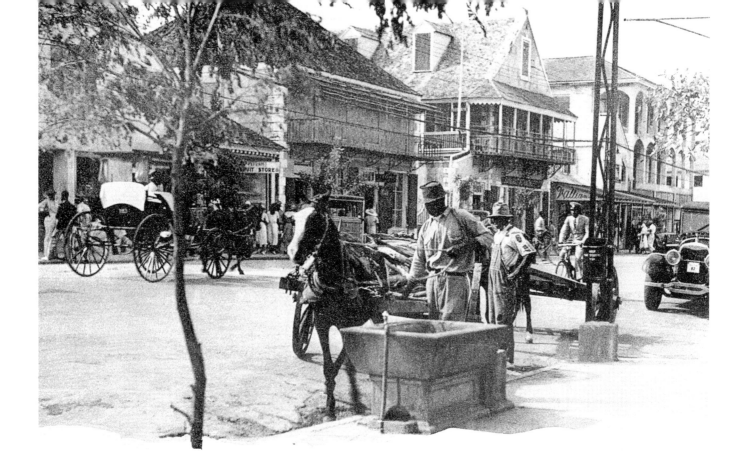

Nassau was bustling with activity during the 1920s. The first casino, the Bahamian Club, had opened and new hotels such as the Montagu Beach and the New British Colonial were opening their doors to the increasing numbers of visitors.

However, by 1930, the sponging industry, which had been a major source of income for many families, had come to an abrupt end after a mysterious disease wiped out the sponge beds.

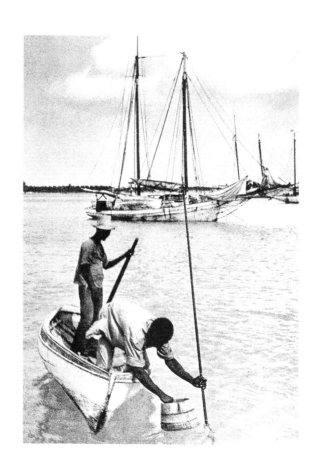

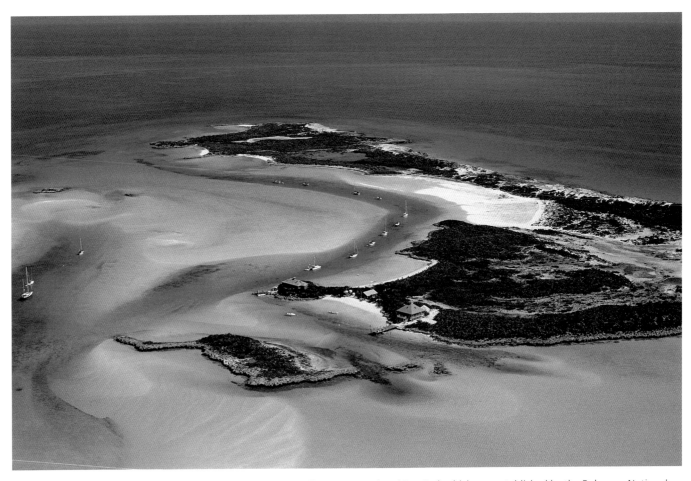

Warderick Wells contains the headquarters of the 175-square mile Exuma Land and Sea Park which was established by the Bahamas National Trust as a replenishment, restoration and nursery area. Today the lush vegetation and abundant sea life that have resulted from a strict 'no touch, no removal' policy attract thousands of visitors each year.

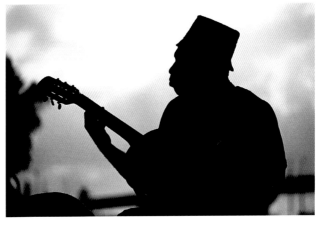

Sunset serenade.

Contemporary writers described these bootlegging years as perhaps the most rewarding of the intermittent periods of illicit activities that Bahamians took advantage of - surpassing piracy, blockade running and wrecking. A great deal of the colony's windfall profits from smuggling were invested in infrastructural improvements. It was during this period, for example, that Nassau Harbour was dredged to allow large ships to dock at the new Prince George Wharf alongside Bay Street for the first time.

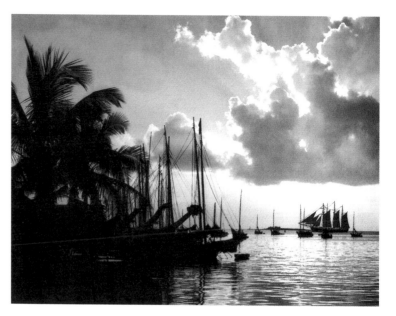

An evening view of Nassau Harbour evoking the romantic days of bootlegging.

A duty-free liquor store on Bay Street.

A view of Gregory Town on North Eleuthera.

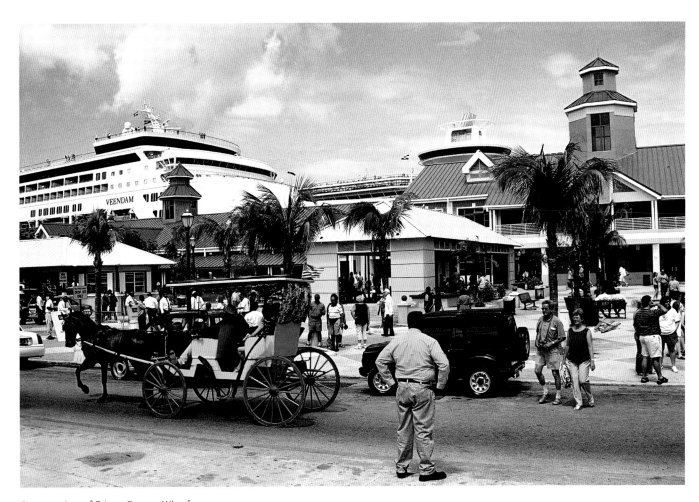

A street view of Prince George Wharf.

These improvements helped the fledgling tourist industry. And The Bahamas also benefited from a real estate boom in nearby Florida to become an 'in' destination for many North American plutocrats. Sea plane services to Nassau by Chalk's Airlines and Pan American Airways began at this time, and the richest visitors often arrived in their own yachts.

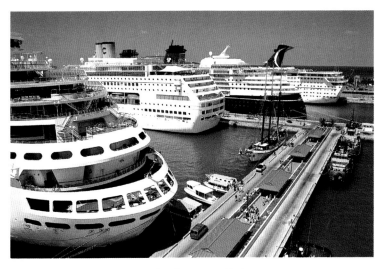

Cruise ships at Prince George Wharf in Nassau Harbour.

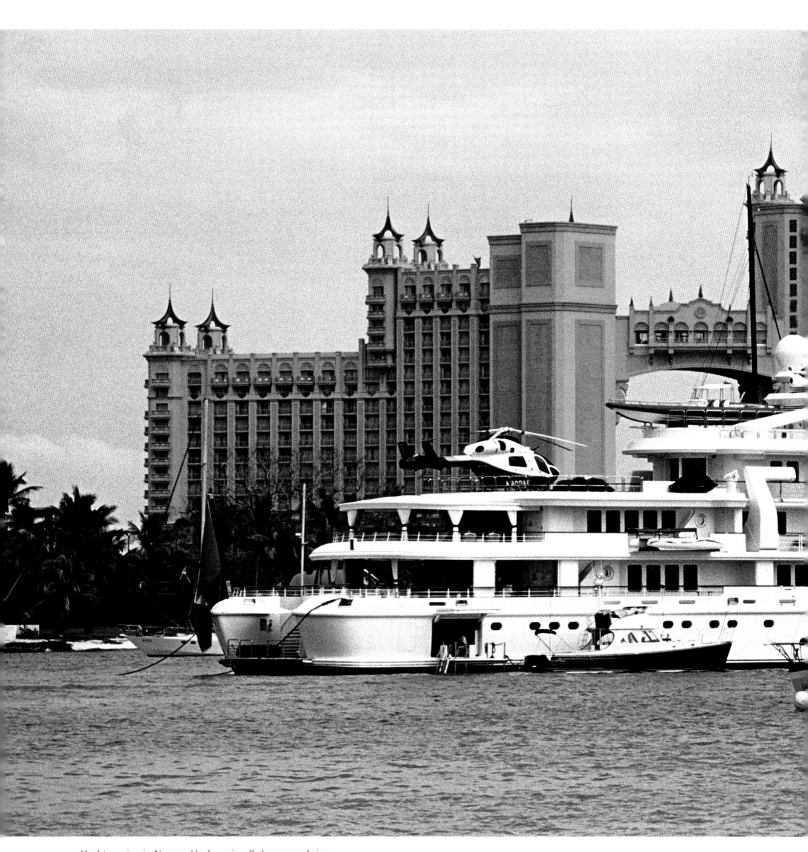

Yachts arrive in Nassau Harbour in all shapes and sizes.

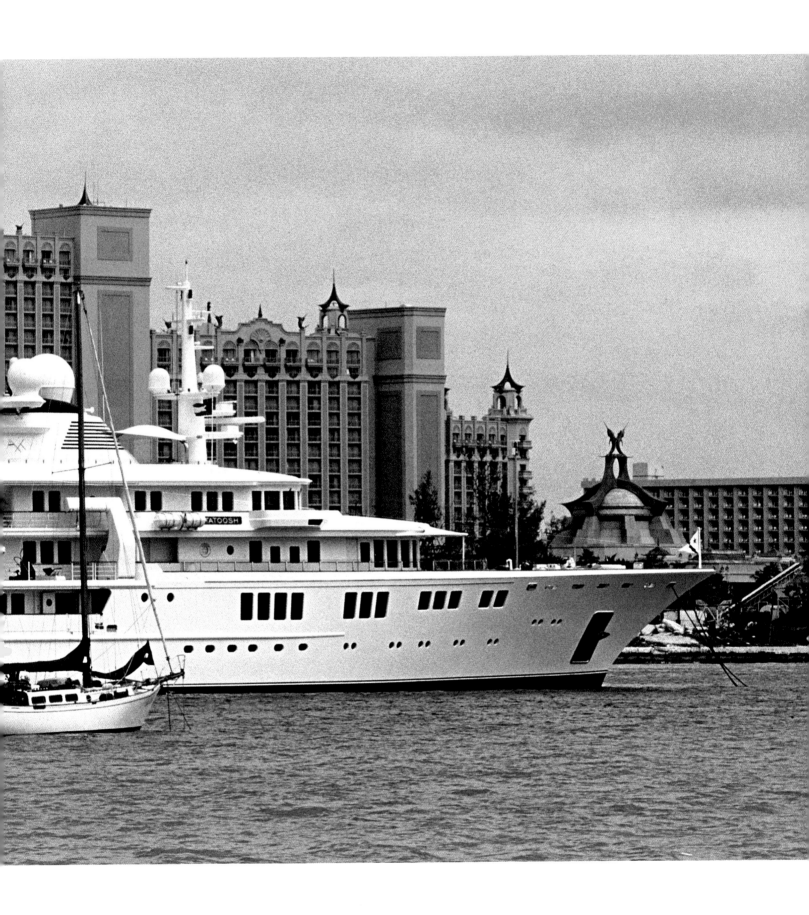

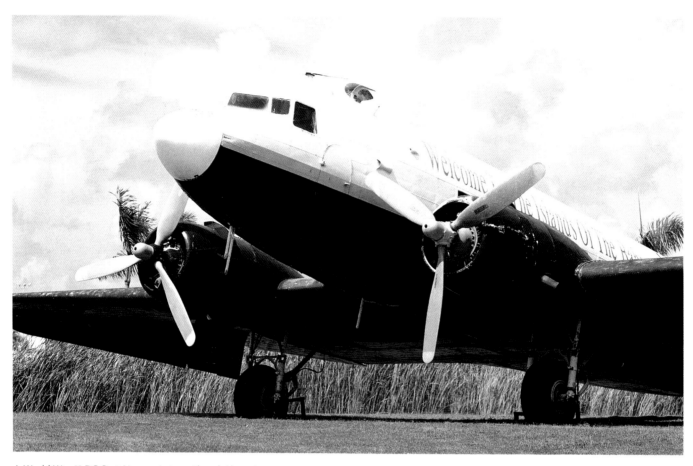

A World War II DC-3 at Nassau International Airport.

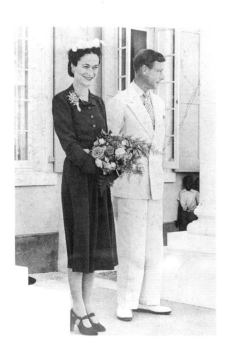

But it was not until after World War II that the country finally found its feet as a leading world travel destination and financial services centre. Both the British and the Americans established air force bases in Nassau for flight training, and bomber crews were shuttled between America and Europe via The Bahamas. Nassau International Airport was built during this time and known as Windsor Field (after the Duke of Windsor, the ex-British king who was marooned here as governor from 1940 to 1945).

The Duke and Duchess of Windsor at an official event in Nassau during the 1940s. Britain's former King Edward VIII caused a major scandal when he abdicated in 1938 to marry American divorcee Wallis Simpson, scion of a respectable Maryland dynasty.

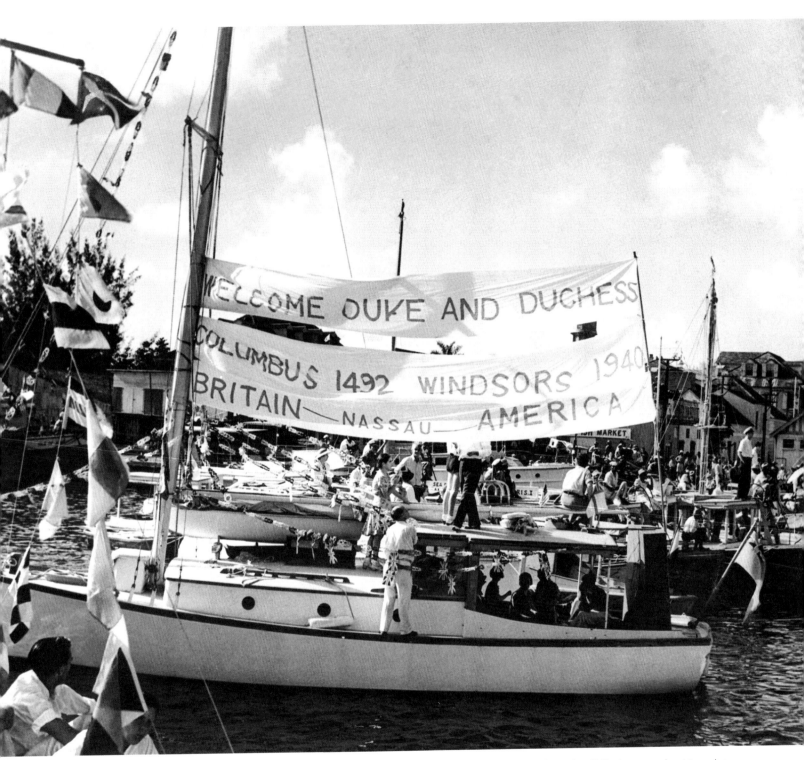

This photo was taken on August 17, 1940 in Nassau Harbour, just as Queen Victoria's great grandson, the Duke of Windsor, was about to arrive by ship to take up his duties as governor. The Duke and Duchess were banished to The Bahamas by the British government for the duration of the war because of their suspected Nazi sympathies. This picture records the motley welcoming ceremony at Prince George Wharf. Although Bahamians generally were impressed with the royal couple, their feelings were not reciprocated. The late Duchess once wrote of Nassau, 'The heat is awful. We both hate (the place) ... the locals are petty-minded, the visitors common and uninteresting'. They left Nassau in 1945. Edward died in Paris in 1972 followed by Wallis in 1986.

Growing post-war prosperity in developed countries coupled with the expansion of travel opportunities worldwide led to a spectacular boom in tourism to The Bahamas beginning in the early 1950s. This growth in travel was complemented by an expansion of the offshore financial services sector, which was based on the country's status as a tax haven.

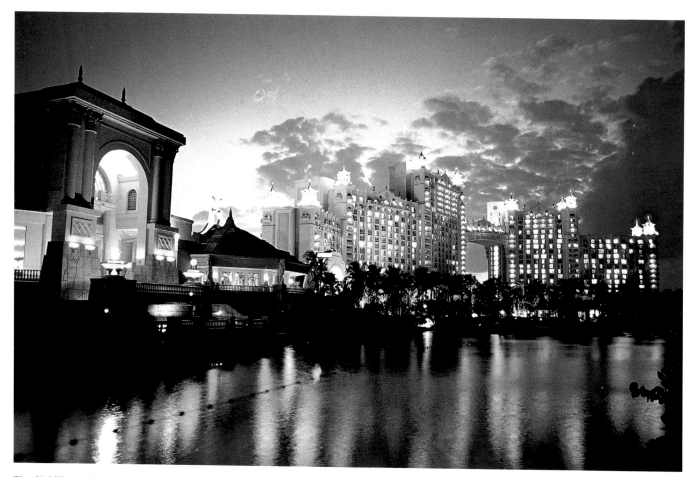

The $1 billion Atlantis Resort rises majestically on Paradise Island as the pinnacle of the vacation industry in The Bahamas.

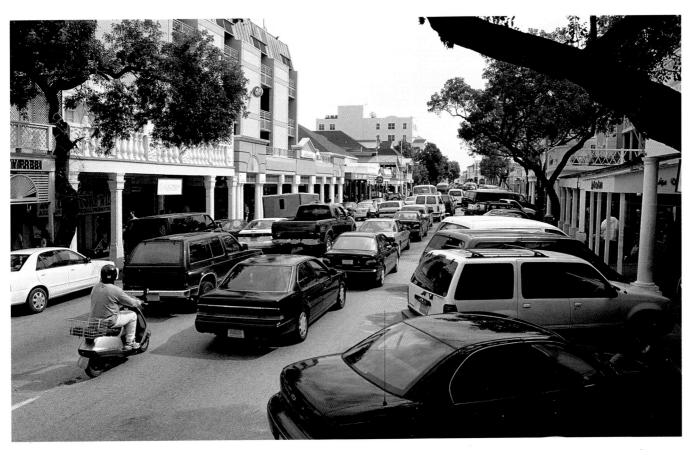

Bay Street has seen many changes over the last 50 years. With the development of large shopping areas and malls in the urban areas of New Providence, most of the traditional clothing and hardware stores have moved and have been replaced with fine restaurants and stores catering to the 3 million visitors each year. The most notable change was the overnight reversal in traffic flow, from westbound to eastbound, which, with over 90,000 vehicles now registered, has brought about some exciting moments!

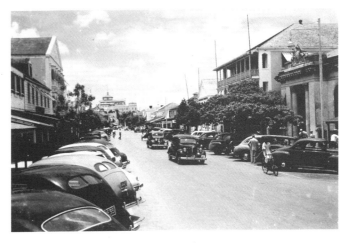

The financial heart of Nassau in the early post-war years.

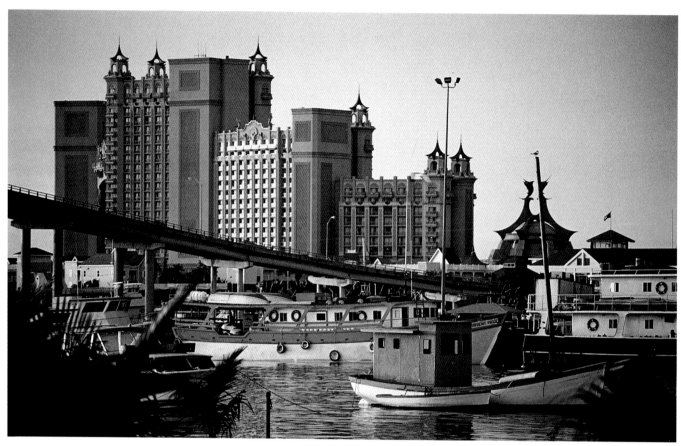

To feed tourists into Atlantis, two bridges link Nassau to Paradise Island – which is probably the most expensive piece of island real estate in the region. The 1,000-acre strip of land bounding Nassau Harbour is the biggest revenue earner in The Bahamas and competes with entire nations elsewhere in the Caribbean. Originally known as Hog Island, the name was changed in the 1960s by American A&P Supermarket's heir, Huntington Hartford, who began its transformation into the glittering resort complex it is today. The island's north shore features some of the world's finest beaches. Inter-island mail boats are docked at Potter's Cay beneath the exit bridge.

Within 50 years the number of annual visitors
rose from 45,000 to more than 4 million,
mostly from North America. The income from
this industry has produced one of the most
remarkable and resilient economies of any
small state in the world. About 60% of these
tourists arrive by sea and the rest by air,
providing more than half the country's jobs
and supporting the third largest per capita
income in the Americas.

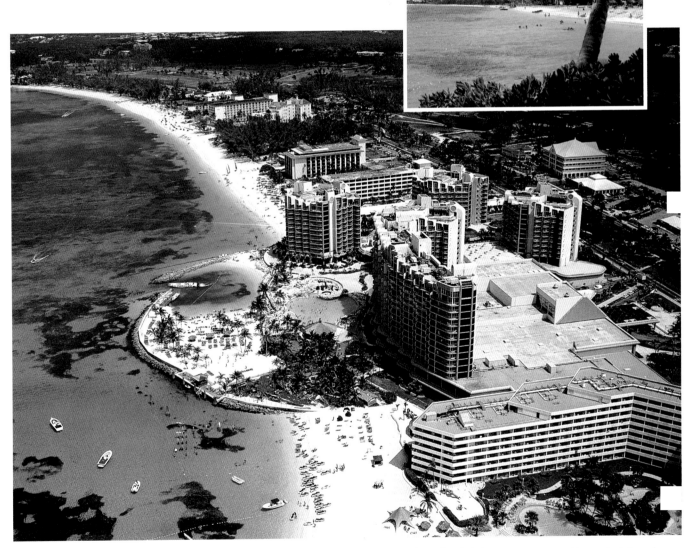

The other main resort complex on New Providence is the Cable Beach strip. Seen here from the air, it incorporates several luxury hotels and
vacation villages. Cable Beach was the spot where the first undersea telegraph link to the United States reached shore.

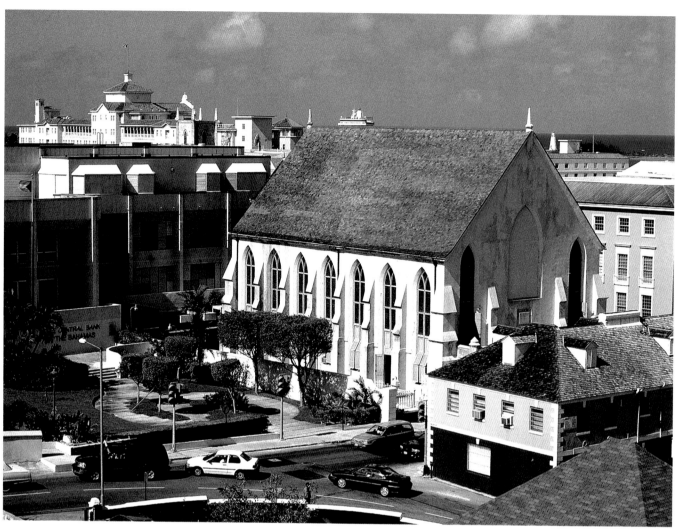

The modern Central Bank of The Bahamas contrasts with many low-rise historic buildings in the heart of the city of Nassau. On the skyline is the British Colonial Hilton, which houses the stock exchange.

Banking and financial services today account for roughly 15% of the economy and directly contribute over $300 million a year in salaries, fees and other overheads. In addition to a well-developed commercial banking network dominated by Canadian institutions, there is a large international offshore sector that provides asset management for affluent individuals.

There are several major golf courses in Nassau/Paradise Island. The most prestigious is at Lyford Cay, a former mosquito-infested tidal creek on the western tip of New Providence that was developed as an enclave for the rich and famous by Canadian investor, E.P. Taylor.

The attractiveness of the Bahamian environment and the resort facilities and transportation links developed to support tourism are important factors in the growth of the financial services sector.

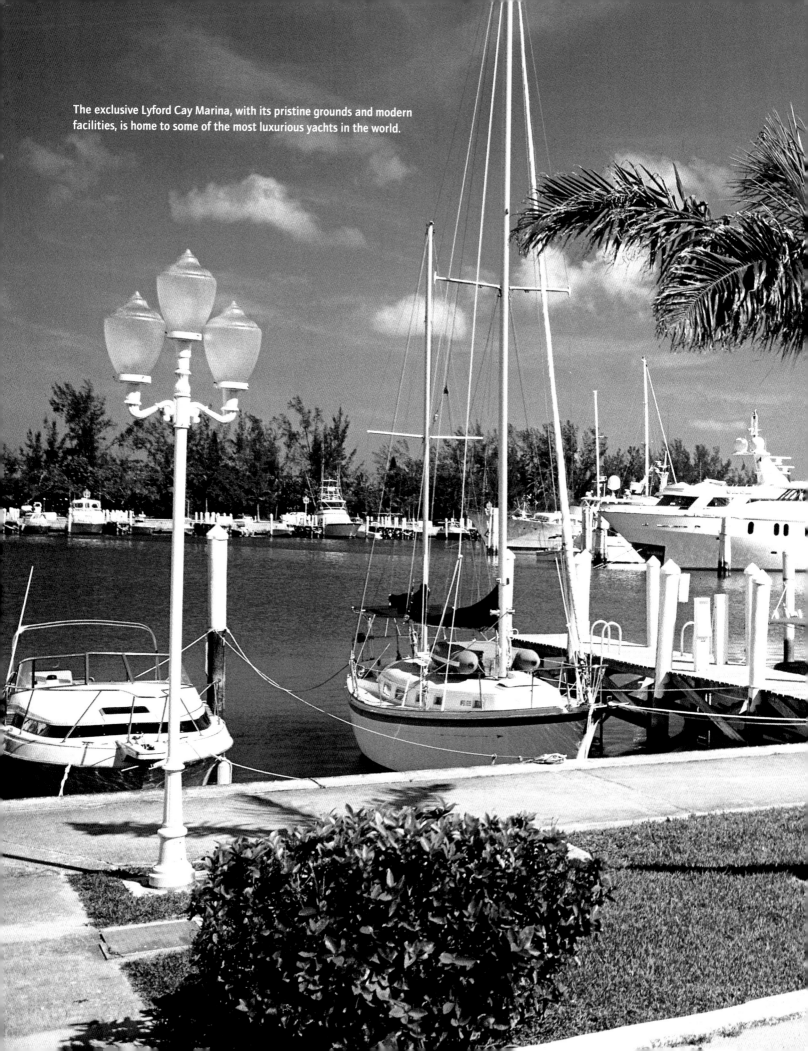

The exclusive Lyford Cay Marina, with its pristine grounds and modern facilities, is home to some of the most luxurious yachts in the world.

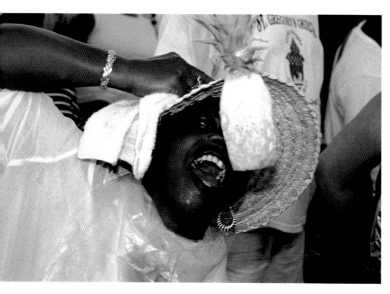

Peasant farmers on the Bahamian Out Islands once produced some
of the world's best pineapples (celebrated at the annual Pineapple
Festival on Eleuthera). The industry failed around the turn of the
20th century due to poor soils and competition from more efficient
producers in Hawaii, Cuba and Louisiana.

Although there are a handful of modern farms on the larger northern
islands producing citrus and winter vegetables, most indigenous Bahamian
agriculture is characterised by pot-hole farming. Thin soils cover the
limestone rock, which is pitted with solution holes that collect more soil
than usual. These are used by small farmers to grow a surprising variety of
vegetables and tropical fruits for the local market.

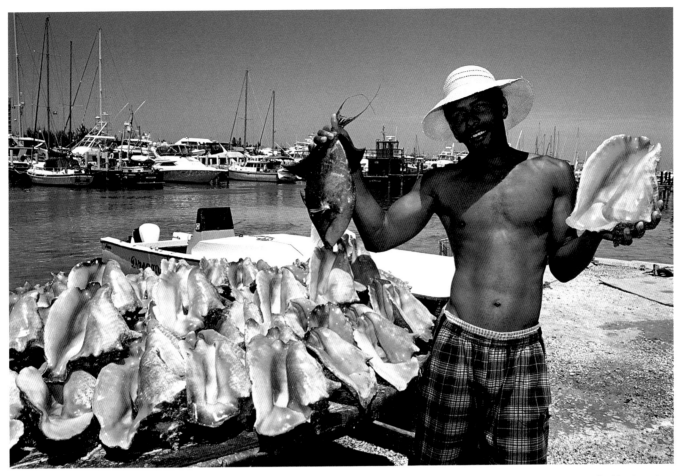

Conch is a favourite Bahamian sea food. The mollusc is pulled from its pink shell and eaten raw, with lime and hot pepper, or cooked in chowders and stews. The shells are sold whole as souvenirs or made into cameo jewellery.

Although farming is relatively limited, The Bahamas has a rich marine environment which supports one of the world's major spiny lobster fisheries as well as the most important remaining fisheries for conch and grouper in the western Atlantic and Caribbean. Commercial fishing generates about $70 million a year in export earnings.

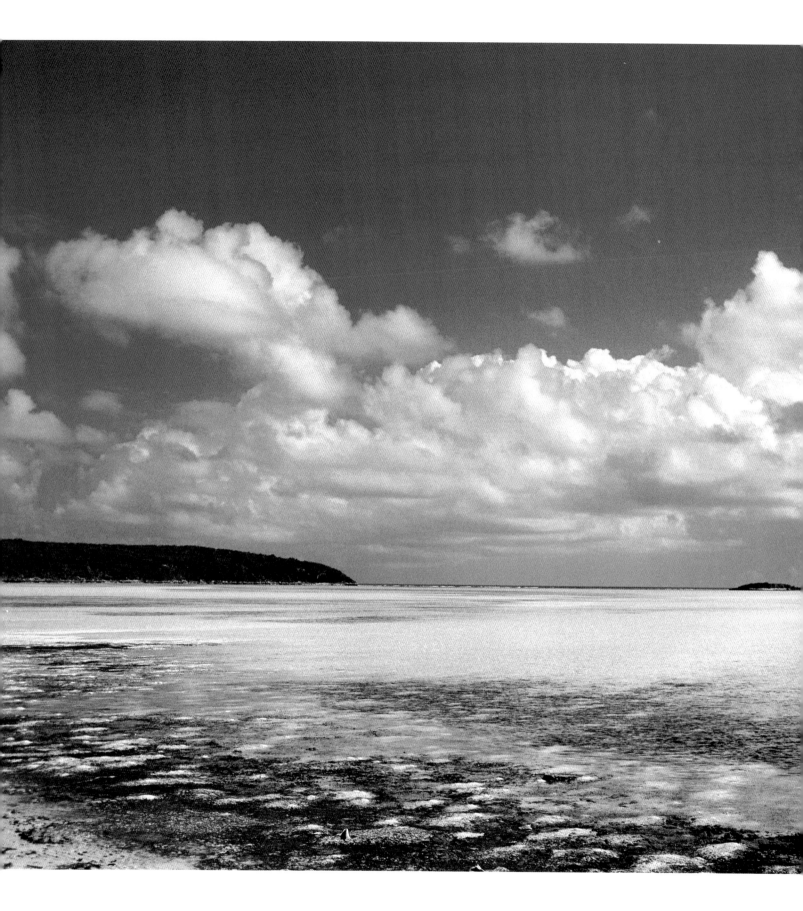

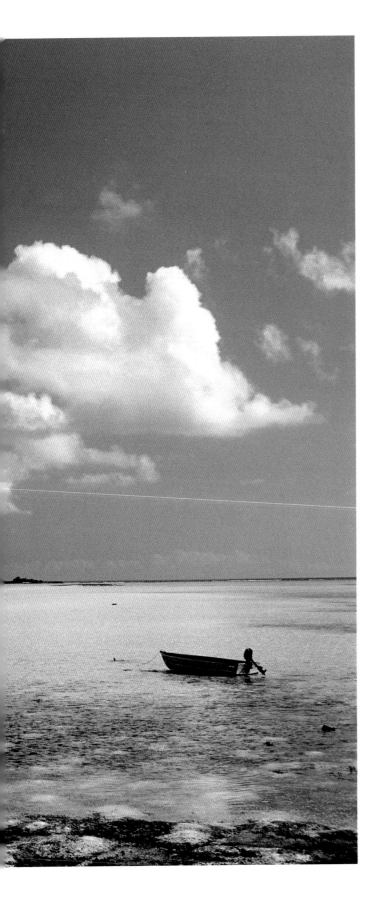

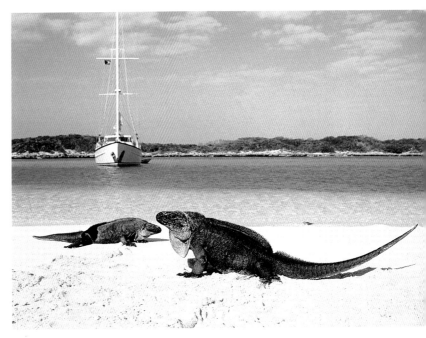

Other than birds and bats, indigenous Bahamian wildlife is mostly limited to non-poisonous snakes, lizards, frogs and insects on land. There are a number of rare iguana species throughout the islands, like these two sunning themselves on a beach in the Exumas.

Bonefish flats, like this one near Old Bight, Cat Island, are popular haunts for local and foreign fly fishermen. Bonefishing is becoming one of the most popular game fish attractions and 'camps' can now be found on most of the islands, patronised by fishermen from all over the world.

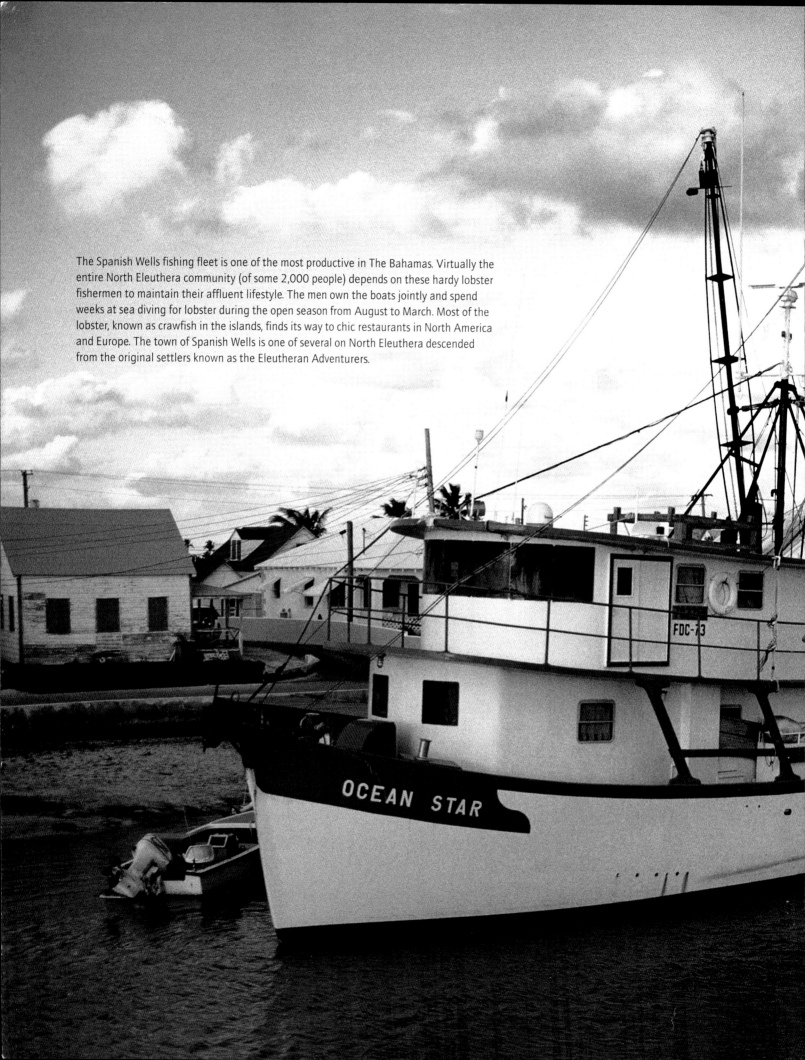

The Spanish Wells fishing fleet is one of the most productive in The Bahamas. Virtually the entire North Eleuthera community (of some 2,000 people) depends on these hardy lobster fishermen to maintain their affluent lifestyle. The men own the boats jointly and spend weeks at sea diving for lobster during the open season from August to March. Most of the lobster, known as crawfish in the islands, finds its way to chic restaurants in North America and Europe. The town of Spanish Wells is one of several on North Eleuthera descended from the original settlers known as the Eleutheran Adventurers.

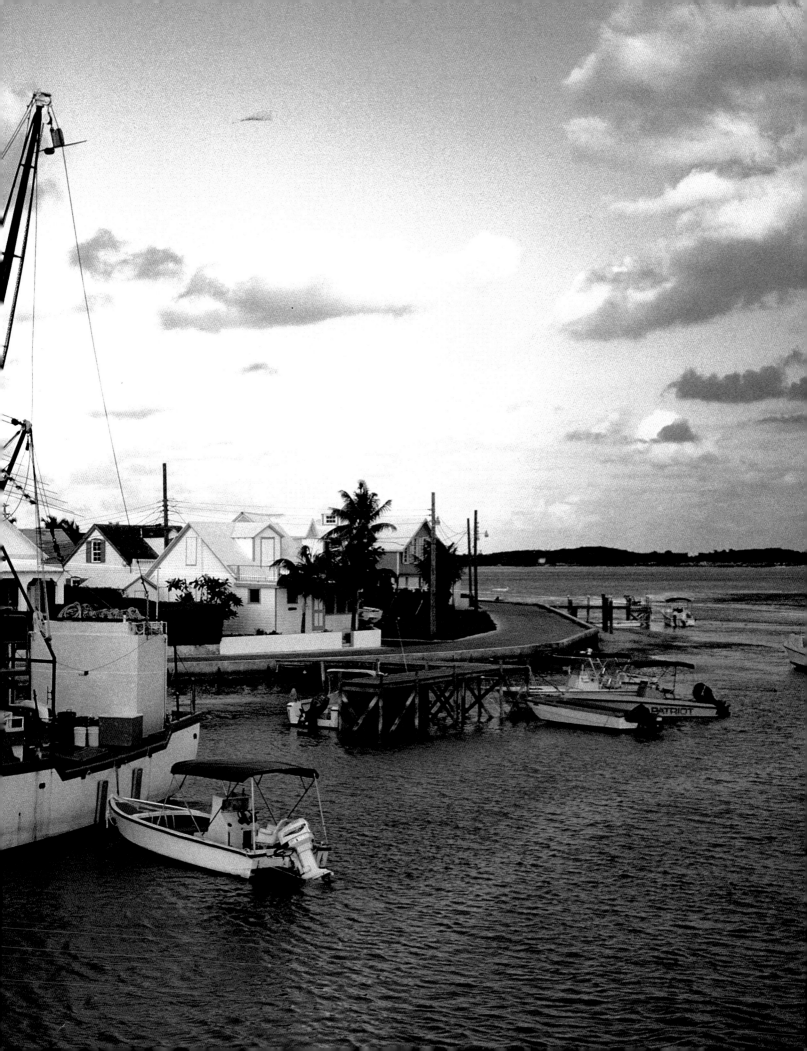

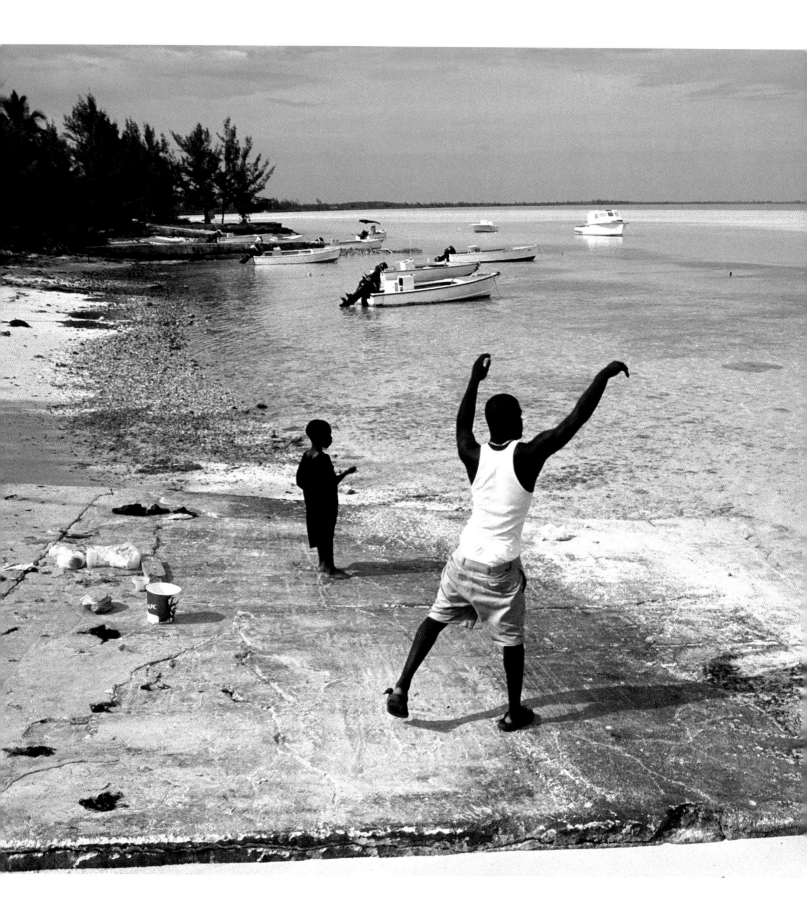

Bahamians can still catch their dinner a short distance from shore as in this photo taken at the Current, North Eleuthera.

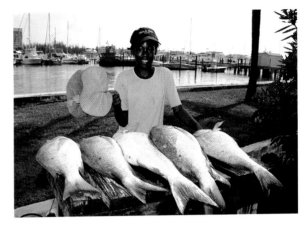

A day's catch in Nassau.

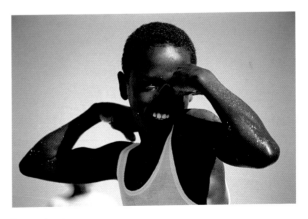

Strong boy!

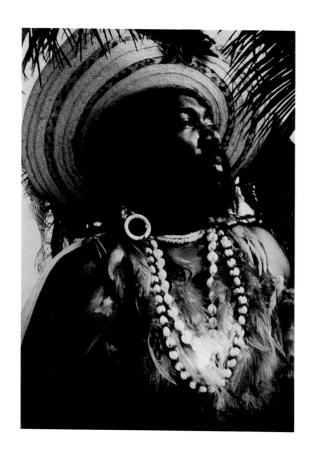

This portrait of Tony McKay was taken at the height of his career as 'the Obeah Man'. McKay was the quintessential Bahamian musician, employing a wide variety of African percussion instruments and drawing heavily on traditional folk songs. He enjoyed some commercial success in the United States during the 1970s and was a favourite among Bahamians until his death in 1997.

Today The Bahamas is run by the descendents of African slaves and European settlers. West African cultural traditions like Junkanoo share prominence with British parliamentary and legal traditions that date back to the first meeting of the House of Assembly in 1729 under Governor Woodes Rogers, giving The Bahamas the distinction of having one of the hemisphere's oldest legislatures.

Children at play.

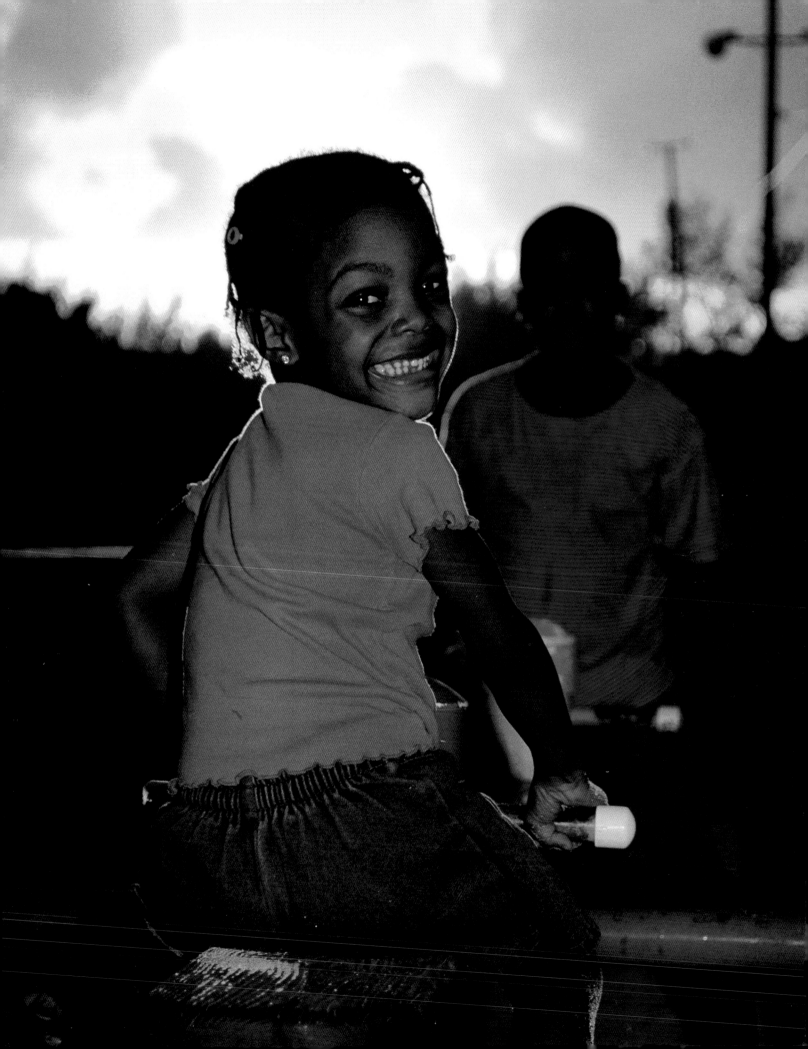

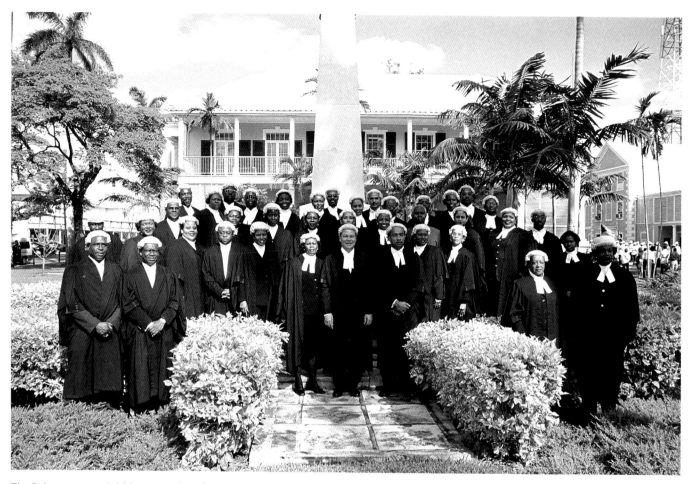

The Bahamas was a British crown colony for over 300 years and British common law is enshrined in the constitution. Bahamian lawyers still train at the Inns of Court in London, refer to judges as 'My lord', and argue their cases in wigs and gowns.

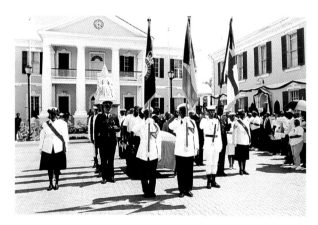

A ceremonial guard of honour in Nassau's Parliament Square. Bahamians are still fond of their British-derived pomp and pageantry.

Political parties did not form until the 1950s and since the British devolved most power in 1964, the country has achieved rapid political progress. The tradition of white minority government was broken by the 1967 general election which established majority rule by Bahamians of African descent (who comprise 85% of the total population) for the first time, and full independence from Britain followed in 1973. Bahamians of all races have voted peacefully in regular free elections ever since.

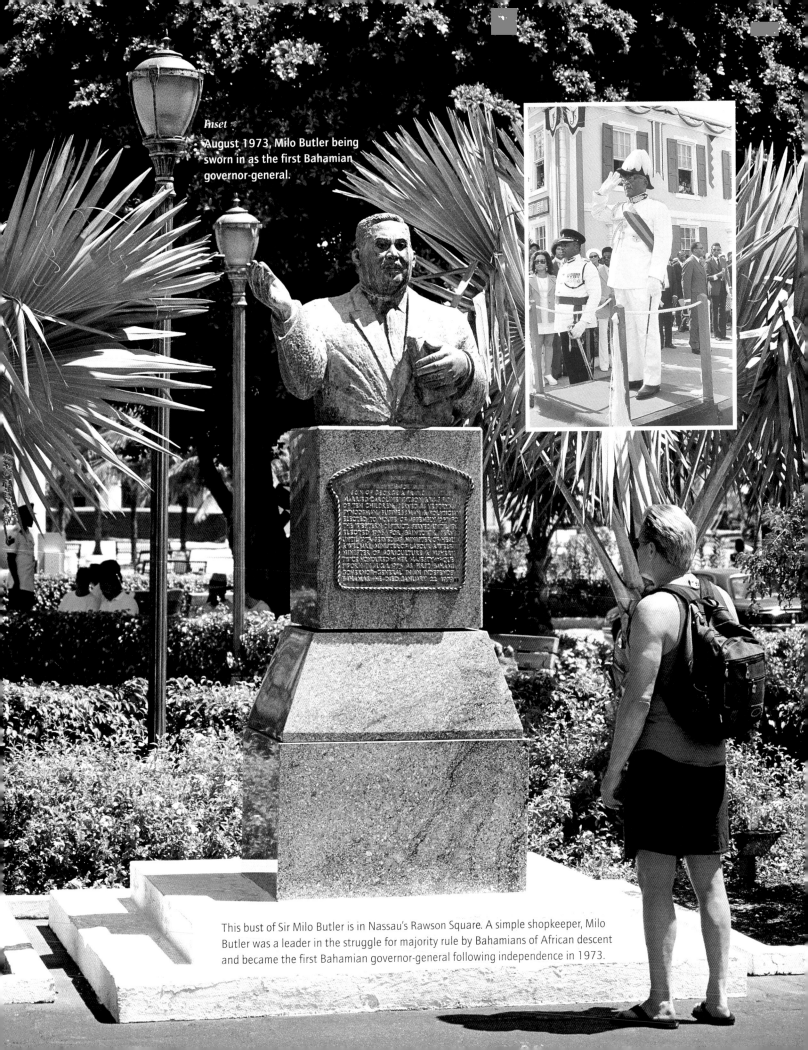

Inset

August 1973, Milo Butler being sworn in as the first Bahamian governor-general.

This bust of Sir Milo Butler is in Nassau's Rawson Square. A simple shopkeeper, Milo Butler was a leader in the struggle for majority rule by Bahamians of African descent and became the first Bahamian governor-general following independence in 1973.

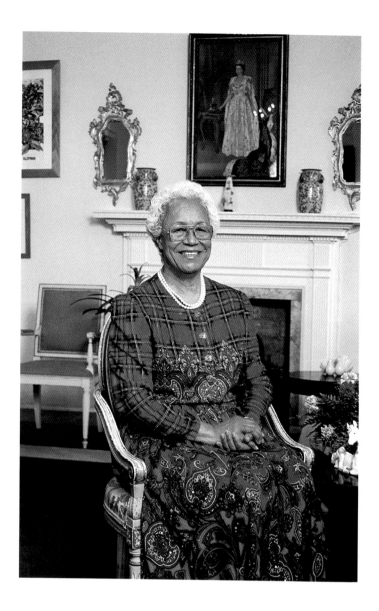

The current (at this writing) Bahamian governor-general, Dame Ivy Dumont, is the first women to hold this largely ceremonial post. She is a former teacher and civil servant. The governor-general acts as the official representative of Queen Elizabeth II who, as head of the British Commonwealth of Nations, remains Queen of The Bahamas.

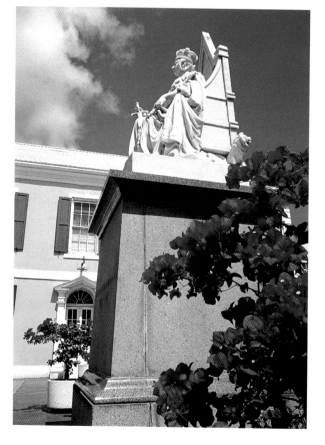

This famous statue of Queen Victoria was erected in Rawson Square in 1905 by the Bahamas branch of the Imperial Order Daughters of the Empire. Although the Order still exists here in the form of a few elderly ladies, the statue represents a bygone age when the British Empire straddled the globe and The Bahamas was a minor imperial outpost.

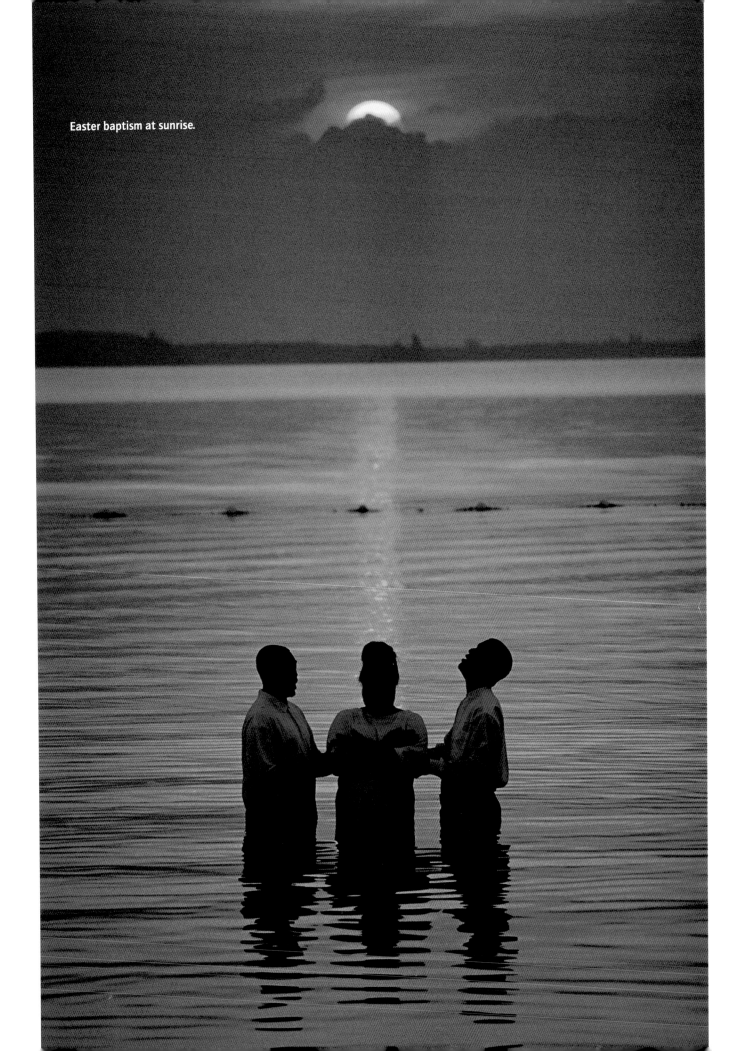

Easter baptism at sunrise.

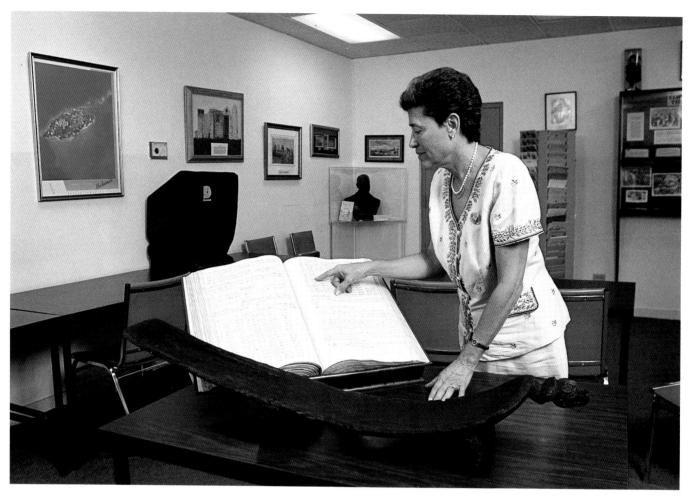

Dr Gail Saunders, OBE, Director of Archives, displays the 1828 Bahamas Register of Slaves. Dr Saunders has been the driving force behind the Bahamas National Archives since its inception in 1991.

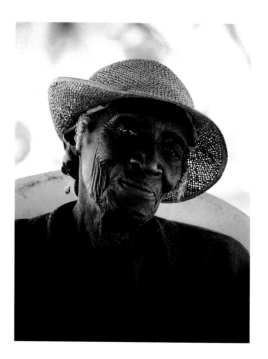

This elderly Bahamian woman of African descent has experienced enormous social changes during her lifetime.

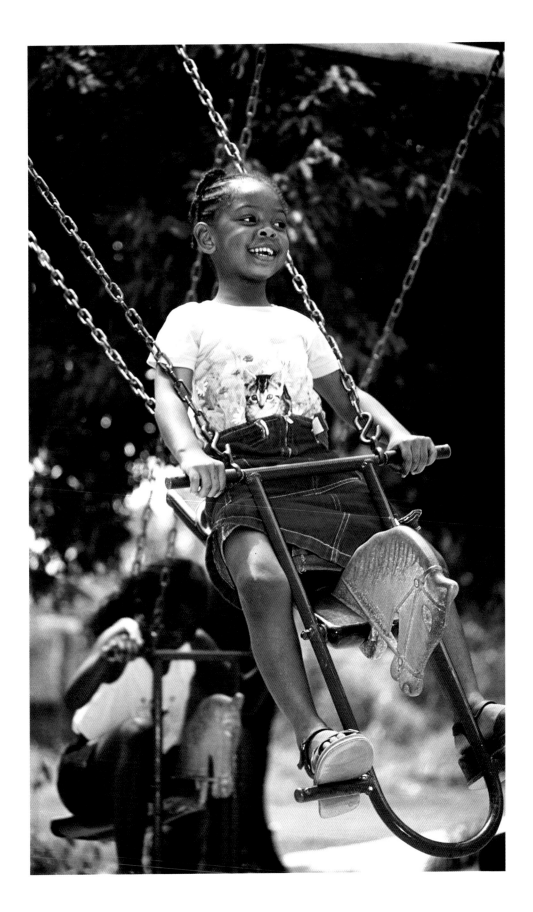

This youngster will experience equally enormous changes in the future.

A dazzling Bahamian shore lapped by an azure sea – just one of many.

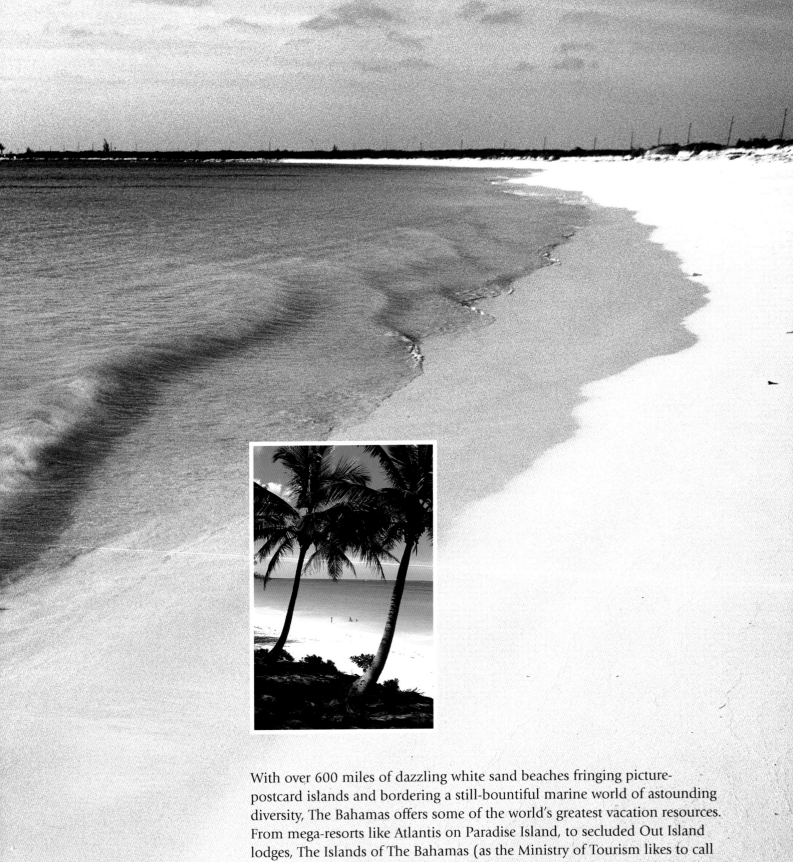

With over 600 miles of dazzling white sand beaches fringing picture-postcard islands and bordering a still-bountiful marine world of astounding diversity, The Bahamas offers some of the world's greatest vacation resources. From mega-resorts like Atlantis on Paradise Island, to secluded Out Island lodges, The Islands of The Bahamas (as the Ministry of Tourism likes to call them) cater to millions of visitors a year who spend well over a billion dollars for the privilege. For a country of just over 300,000 people, this is an astonishing bonanza.

Indeed, that same fractured geography which provided refuge over the centuries for canoe-paddling Indians, Spanish explorers, bloodthirsty pirates, callous wreckers and sundry smugglers today forms the principal attraction for the country's modern visitors.

Regatta time!

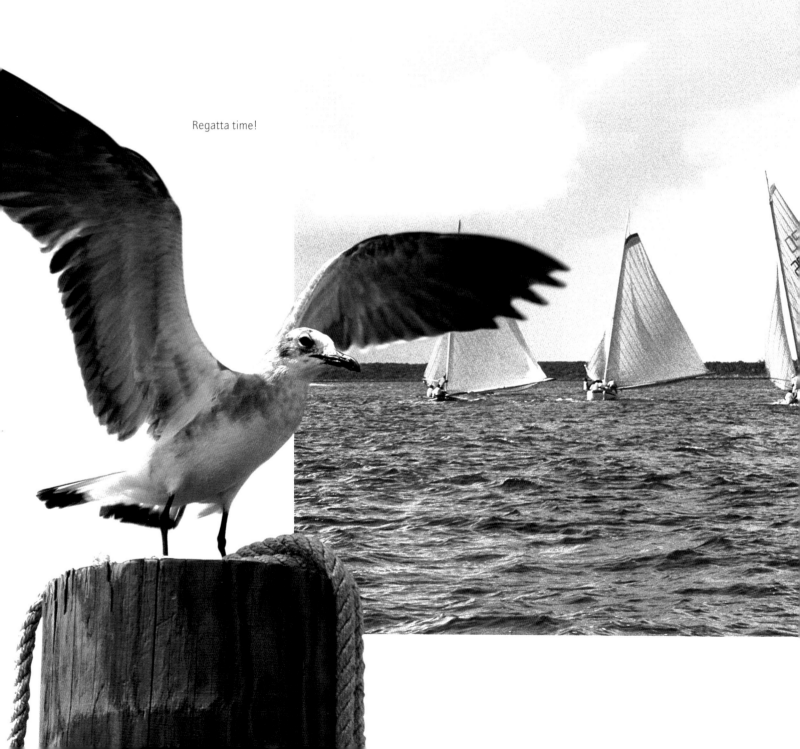

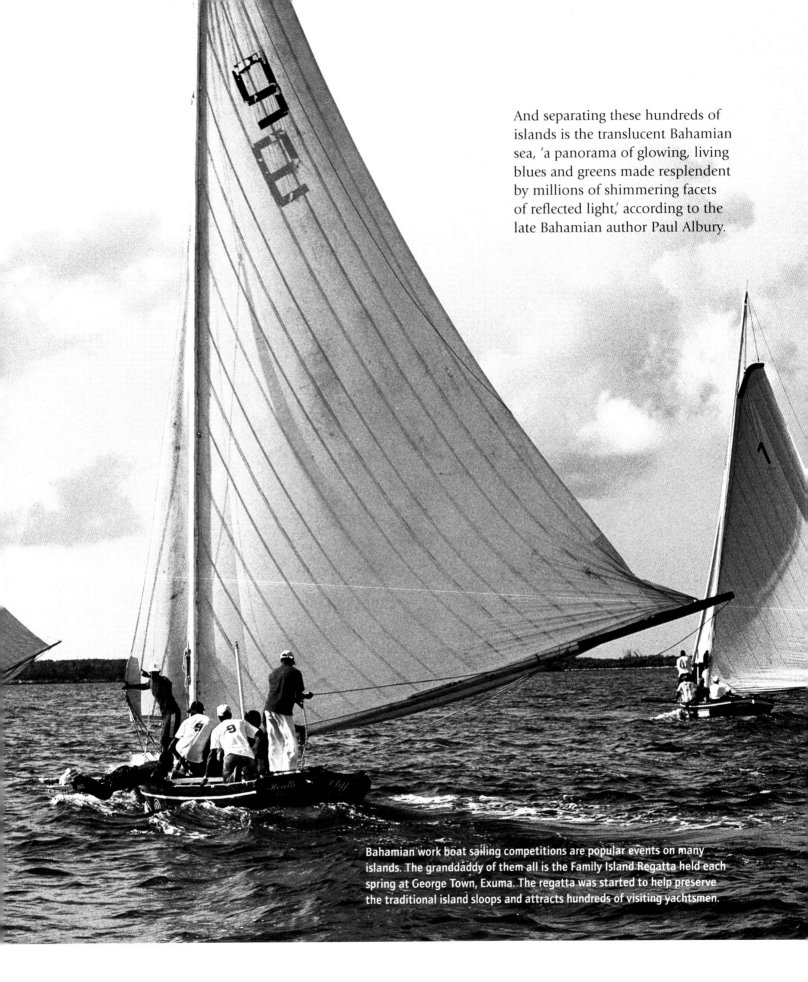

And separating these hundreds of islands is the translucent Bahamian sea, 'a panorama of glowing, living blues and greens made resplendent by millions of shimmering facets of reflected light,' according to the late Bahamian author Paul Albury.

Bahamian work boat sailing competitions are popular events on many islands. The granddaddy of them all is the Family Island Regatta held each spring at George Town, Exuma. The regatta was started to help preserve the traditional island sloops and attracts hundreds of visiting yachtsmen.

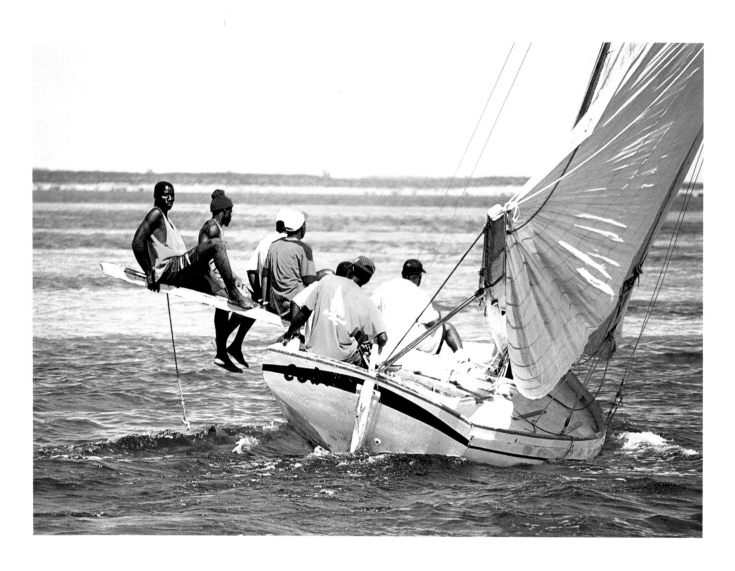

Bahamian racing sloops carry sand bags, rocks and humans as ballast. 'Ridin' de pry' is a nautical term for shifting ballast... sometimes a long way out!

As Paul Albury noted in his *Story of The Bahamas:* 'Much of the mystery and danger has gone from the Bahama sea. And even though the reefs and shallows are as numerous as ever, the safe passages through and around them are now well charted … Present-day explorers cruise The Bahamas with delight and leave it with genuine regret.'

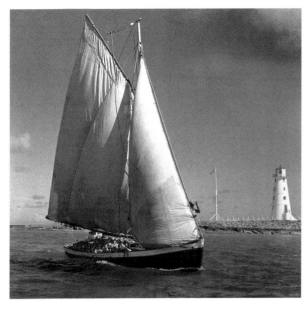

Gaff rigged work boat 'loaded down with conch'.

Opposite page
Time out!

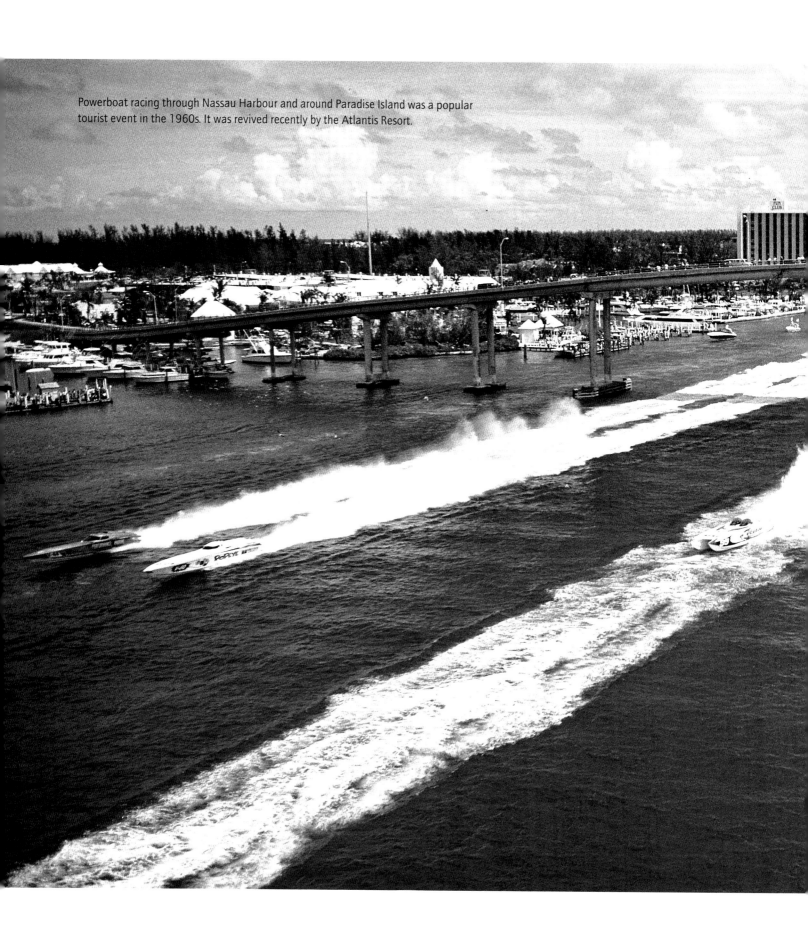

Powerboat racing through Nassau Harbour and around Paradise Island was a popular tourist event in the 1960s. It was revived recently by the Atlantis Resort.

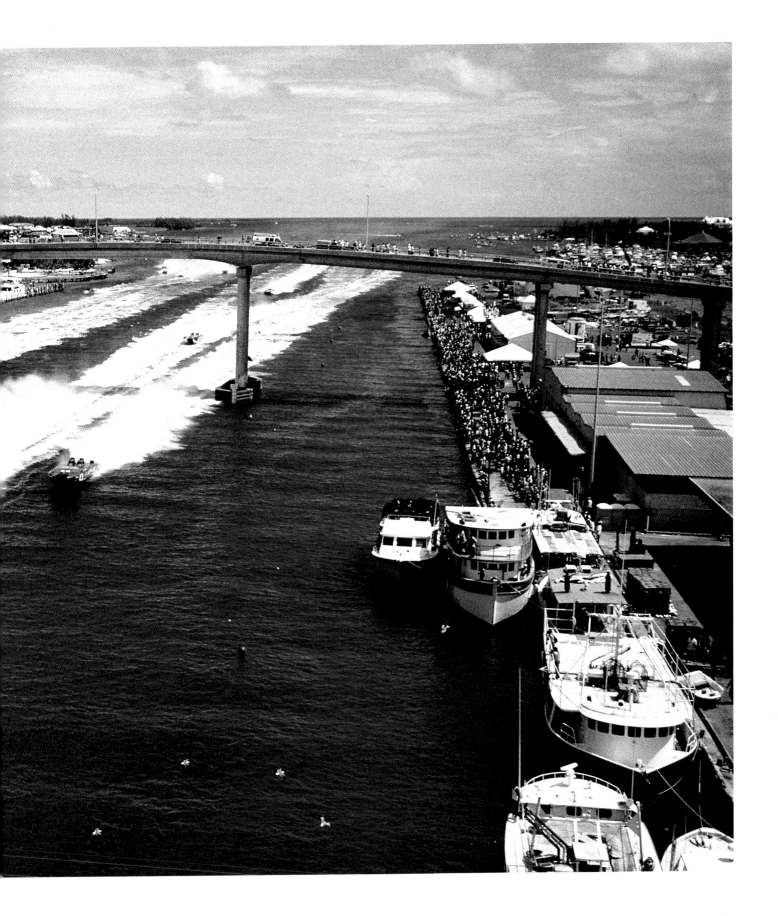

The spectacular casino at the Atlantis Resort on Paradise Island is open for business night and day, manned by shifts of Bahamian and foreign dealers. Bahamian patrons, however, are not allowed to gamble.

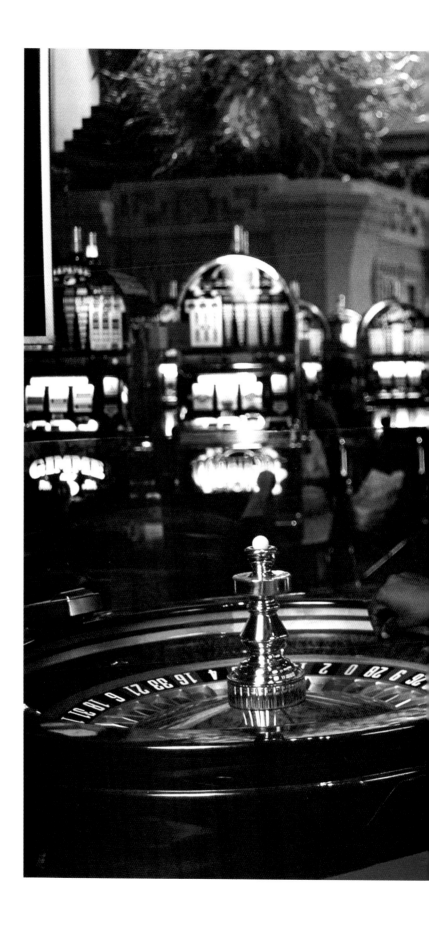

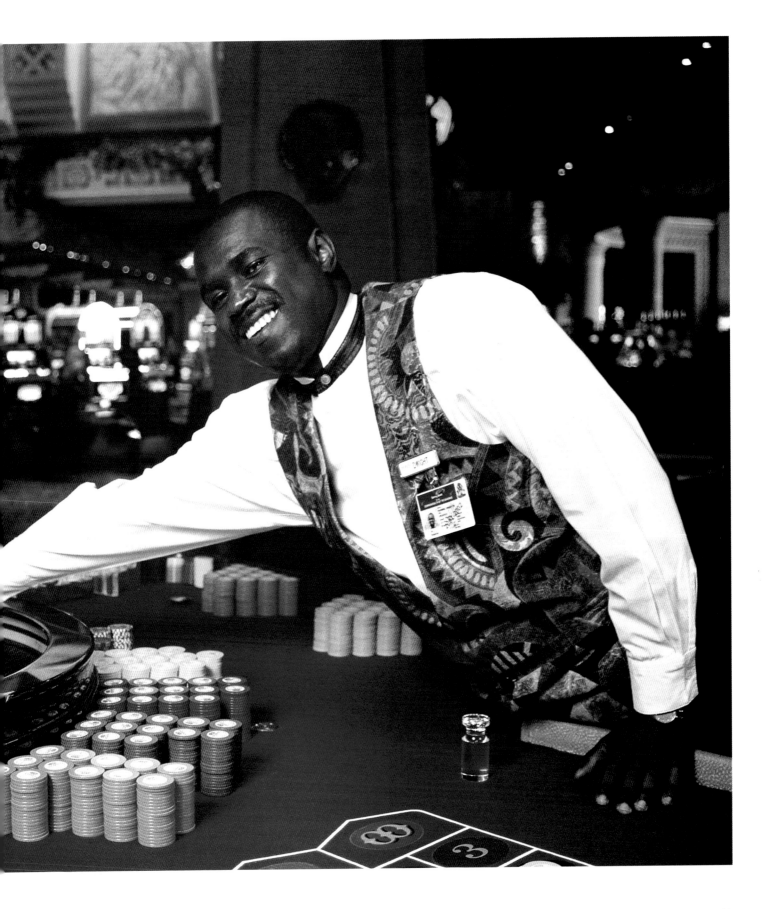

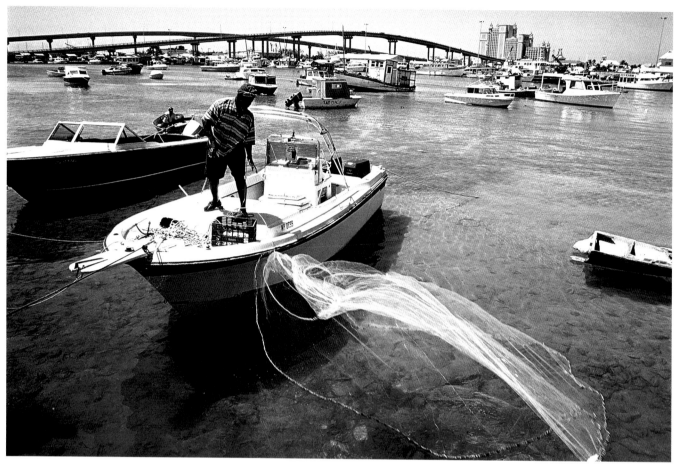

With the slot machines off limits... how about fishing?

This gentleman is casting for pilchards, small sardine-like fish that he will use as live bait to catch groupers. There are just over 15,000 boats registered in The Bahamas and 40% of these are used for recreational purposes.

The annual 'Crab Festival' on Andros Island celebrates the love Bahamians have for this native delicacy. Blue, Black and other types of crab are found in abundance on most of the Family Islands and are prepared in a variety of ways including baked crab cake and creamy crab soup.

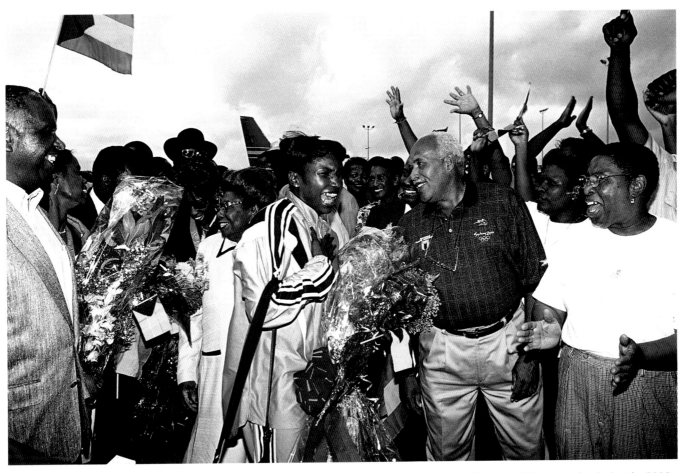

Bahamas golden girl Pauline Davis-Thompson returns to Nassau in triumph after winning a gold medal in the 100-metre relay during the 2000 Olympic Games. The first Bahamian gold medal was captured in Japan in 1964 by Olympic sailor Sir Durwood Knowles.

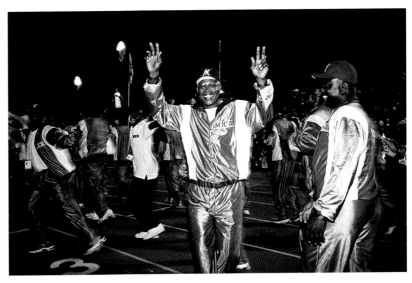

Sports are enjoyed throughout the year, culminating in the Olympic styled 'Bahama Games' with fierce competition between the islands, to the delight of thousands.

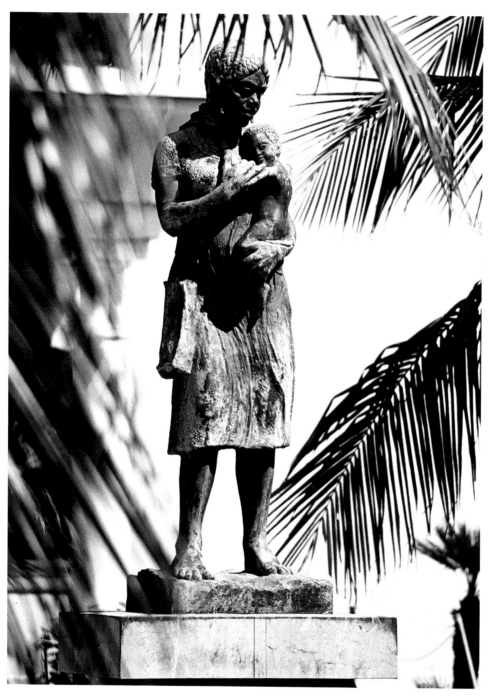

This Randolph Johnston sculpture, 'Bahamian Woman', stands at the Port of Nassau. It is a vivid reminder of the bond between mother and child and a tribute to the determination and self reliance of the naturalised Bahamian artist who in the 1950s, discouraged by the prospect of a materialistic and conformist way of life, gave up his teaching position in Massachusetts and with his young family found his own piece of paradise; a place for artistic study and production, and a natural environment for the growth and development of his children.

Although Mr Johnston passed away in 1992, the foundry, shop and studio he created in Little Harbour, Abaco are still maintained by his son, Peter.

The Milo Butler bronze statue on page 65 is also by Randolph Johnston.

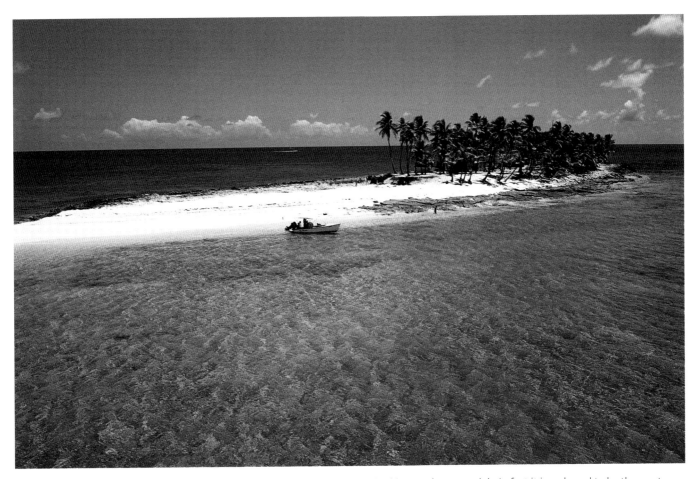

Sandy Cay, a private atoll off New Providence, can be seen in many films, music videos and commercials. In fact it is reckoned to be the most photographed island in the world!

The Bahamas has always attracted artists and photographers who have recorded the beauty and serenity of these islands - from the English naturalist Mark Catesby who illustrated Bahamian wildlife in the 1700s, to American artist Winslow Homer who painted island seascapes in the 1890s, to early movie makers who took advantage of the crystal-clear Bahamian seas to record the world's first underwater scenes.

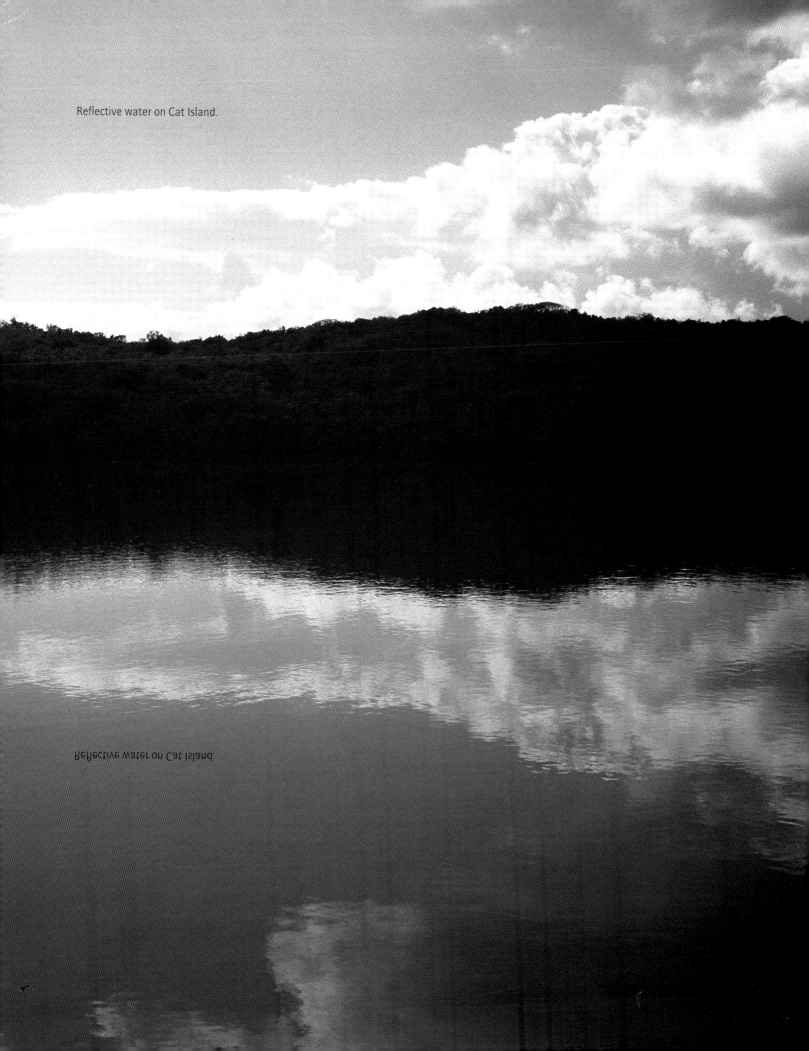

Reflective water on Cat Island.

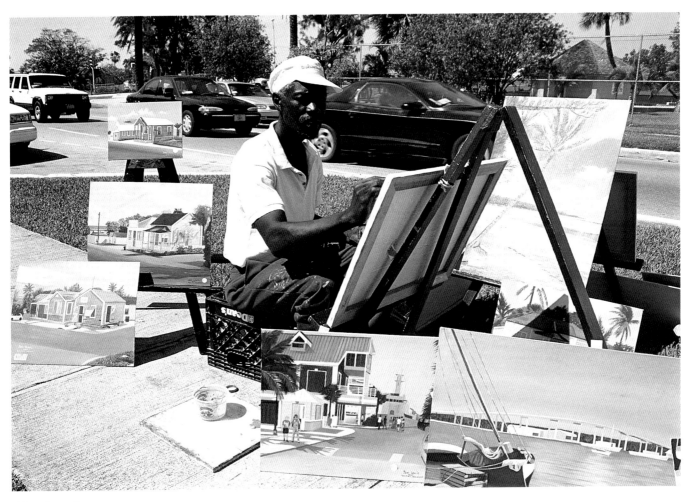

Sidewalk studio.

One of these artists was a commercial photographer named Stanley Toogood who emigrated to The Bahamas from Bournemouth, England in 1934 and catalogued the growth of the modern Bahamas until his death in 1987 at the age of 75.

Photo study: 'We'll fix it t'mara'.

This portrait of the islands is created by Toogood's son, Michael, himself an accomplished artist and boat builder who took over his father's studio in Nassau. Entirely self-taught, Michael has been a freelance photographer in Nassau for over 20 years.

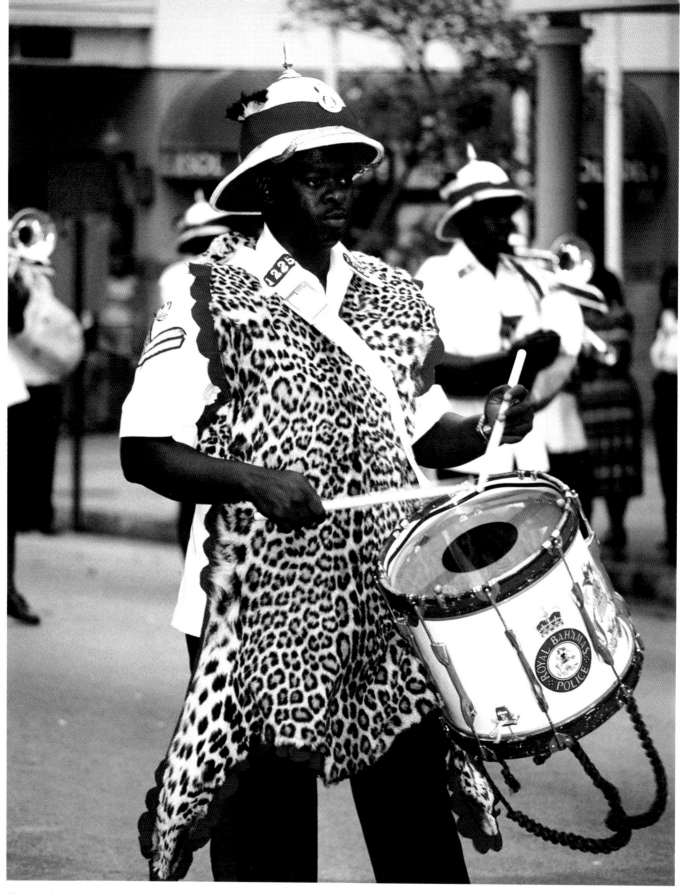

The Royal Bahamas Police Force Band, whose repertoire ranges from traditional marches to upbeat calypso, is enjoyed by many at official functions and celebrations both in The Bahamas and throughout the world and continues to represent the spirit and professionalism of this nation.

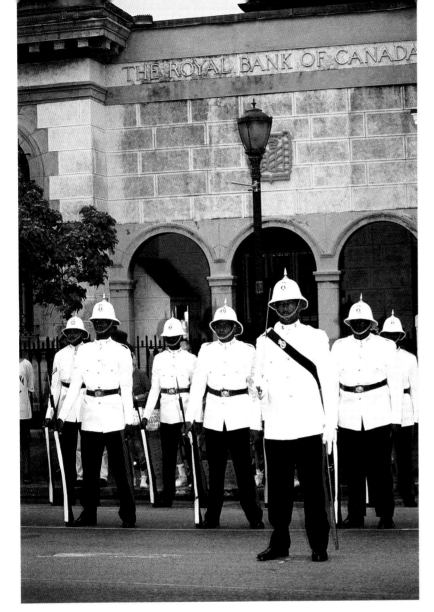

For many years the Royal Bahamas Police Force was the country's only militia. A coast guard was created after independence to interdict drug smugglers and fish poachers.

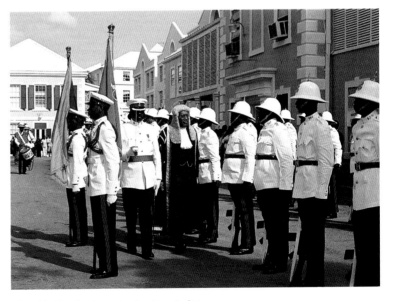

The Chief Justice inspects the Guard of Honour.

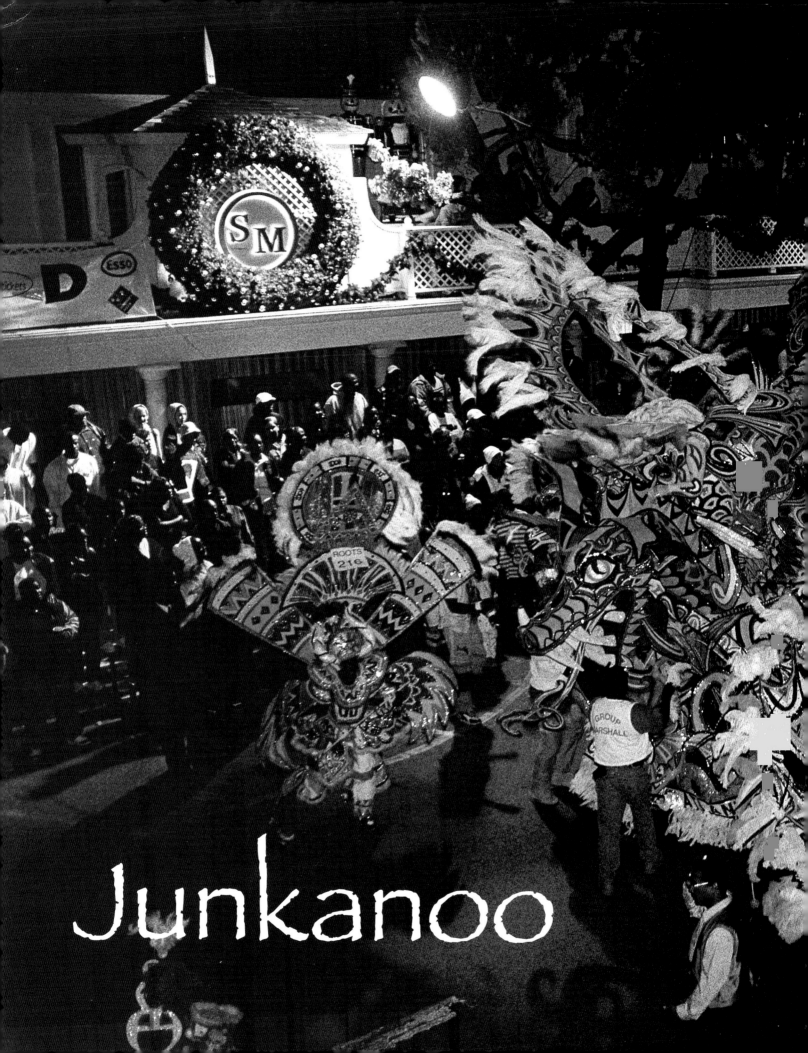

Junkanoo

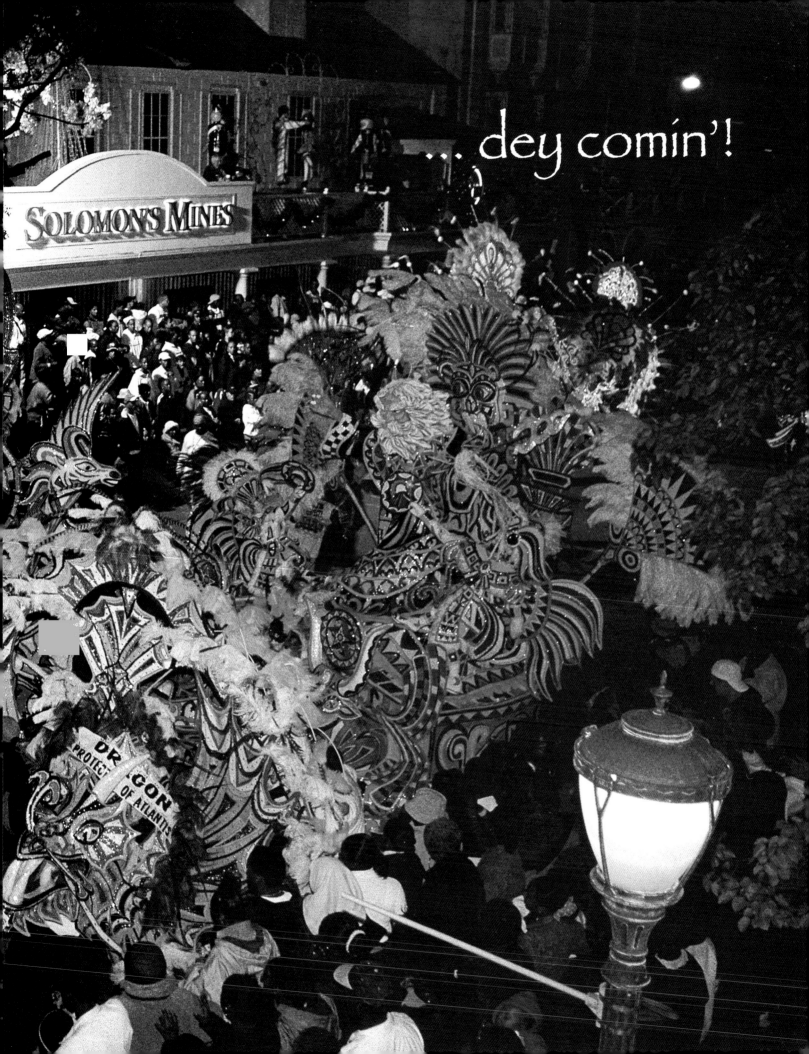

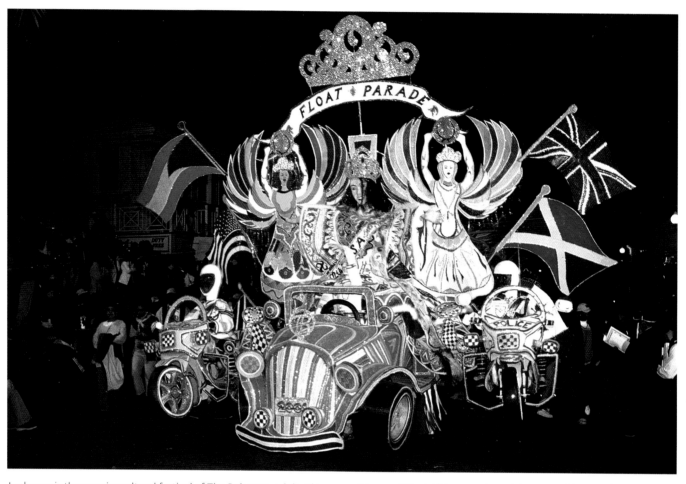

Junkanoo is the premier cultural festival of The Bahamas, originating as a mèlange of West African music and dance traditions performed by the slaves at Christmas time. It has since developed into a spectacular annual costumed carnival that inspires the most colourful creations and is accompanied by mesmerising rhythms. Junkanoo groups can spend months and tens of thousands of dollars preparing for the parades, which are held on Bay Street in the early morning of Boxing Day and New Year's Day.

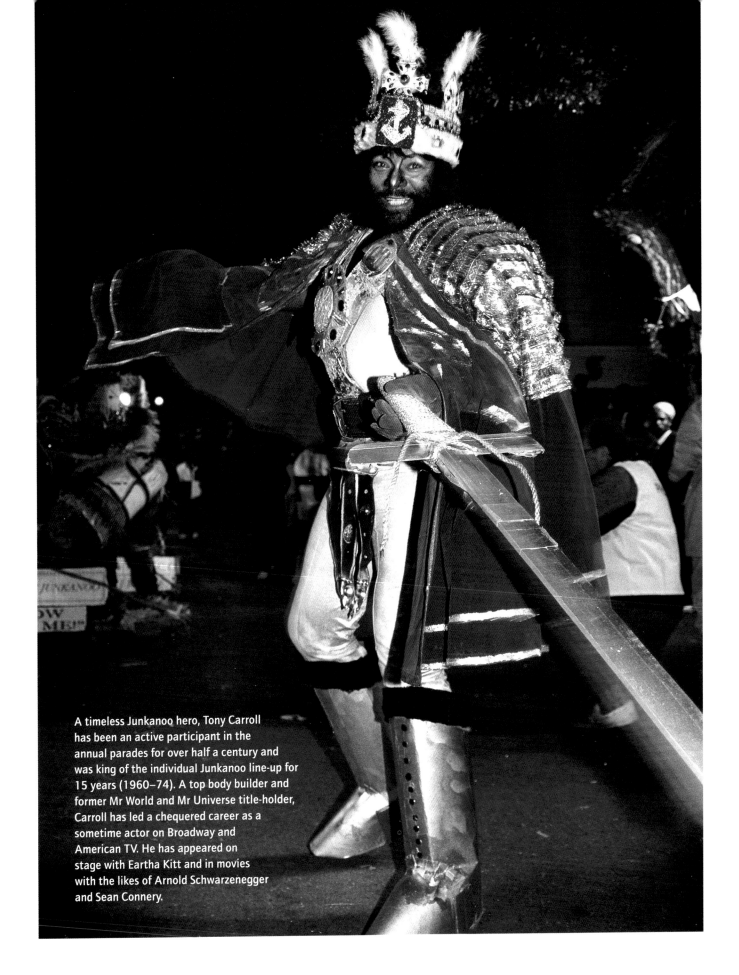

A timeless Junkanoo hero, Tony Carroll has been an active participant in the annual parades for over half a century and was king of the individual Junkanoo line-up for 15 years (1960–74). A top body builder and former Mr World and Mr Universe title-holder, Carroll has led a chequered career as a sometime actor on Broadway and American TV. He has appeared on stage with Eartha Kitt and in movies with the likes of Arnold Schwarzenegger and Sean Connery.

Junkanoo

Although Junkanoo was traditionally a Christmas and New Year's Day event, it is now becoming an important part of the cultural identity of The Bahamas and is being showcased throughout the year. Junkanoo exhibits, hands-on demonstrations and, most importantly, 'rush-outs' are being set up at major venues and marketed worldwide by the Ministry of Tourism. More and more visitors are being exposed to this wonderful cultural experience.

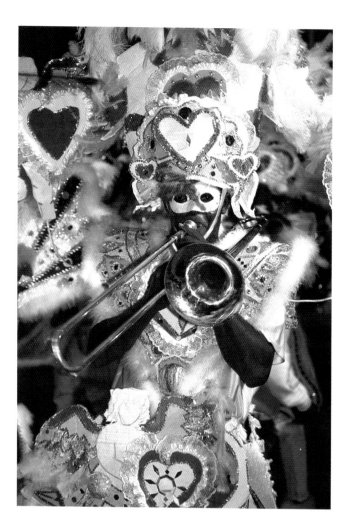

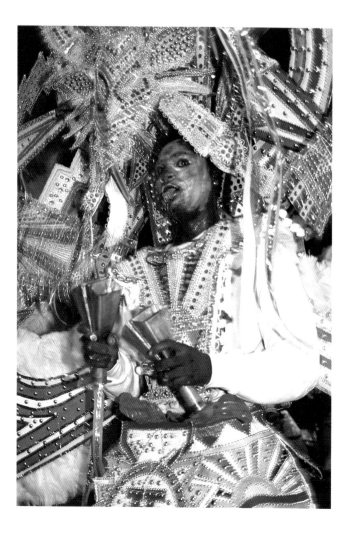

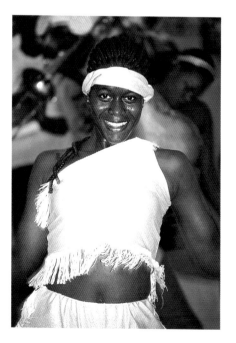

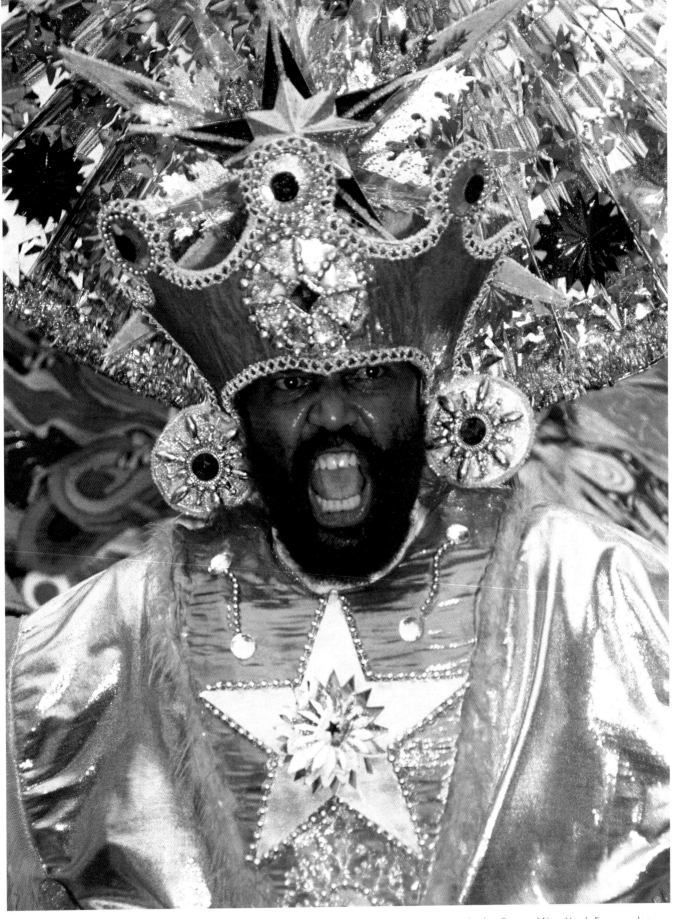

Percy 'Vola' Francis, the dynamic leader of the Saxon Superstars Junkanoo group that has won many Boxing Day and New Year's Eve parades.

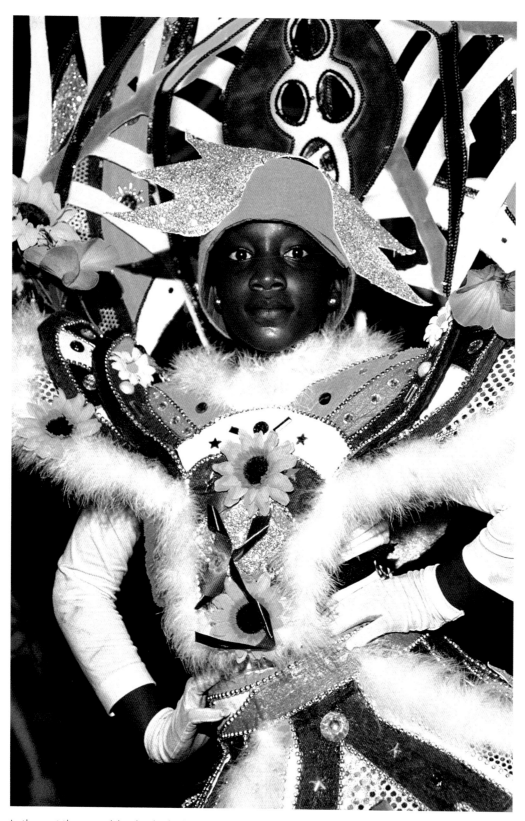

In the past those participating in the 'rushing' were mostly males. However, today men and women, boys and girls join in the festivities.

Junkanoo in June is an example of the increasing effort to draw attention to the uniqueness of Bahamian culture. Month-long activities culminate on 10 July for Bahamian Independence. The spectacle takes place at the 'Fish Fry' on Arawak Cay, a large open area with colourfully decorated eateries where visitors and locals interact and savour native food, drink and music or just mingle.

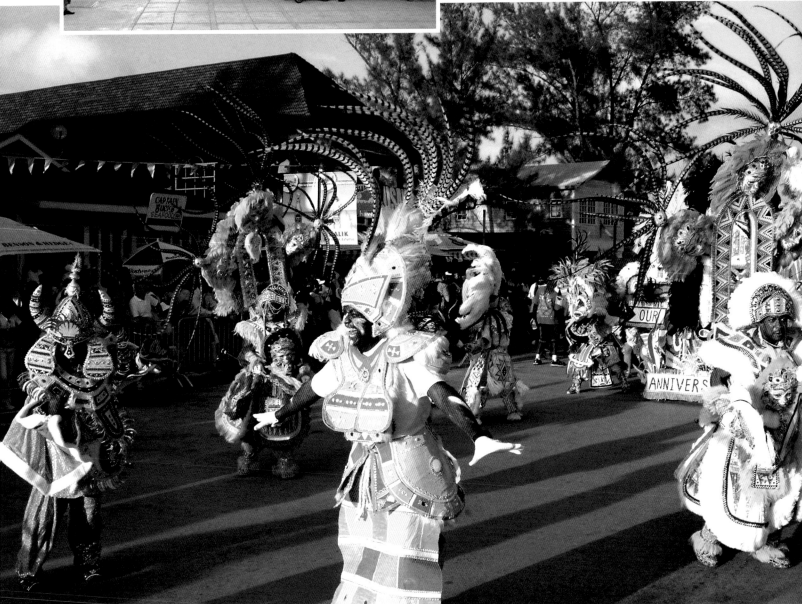

Natural Wonders

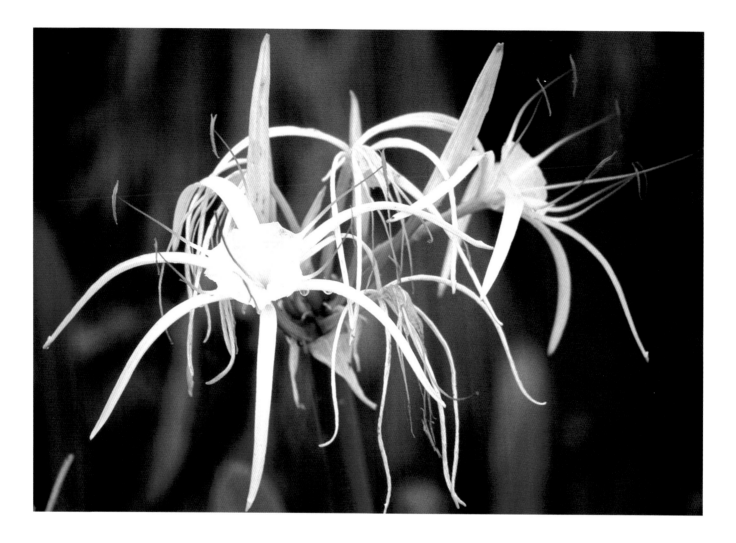

Bahamian horticulture is very diverse, from coarse, salt-loving seashore and dune plants, to flowering shrubs and lush pine forests. If it has leaves, there is probably one of its kind found growing here. The lily shown above and the ubiquitous hibiscus were introduced by early inhabitants of the islands.

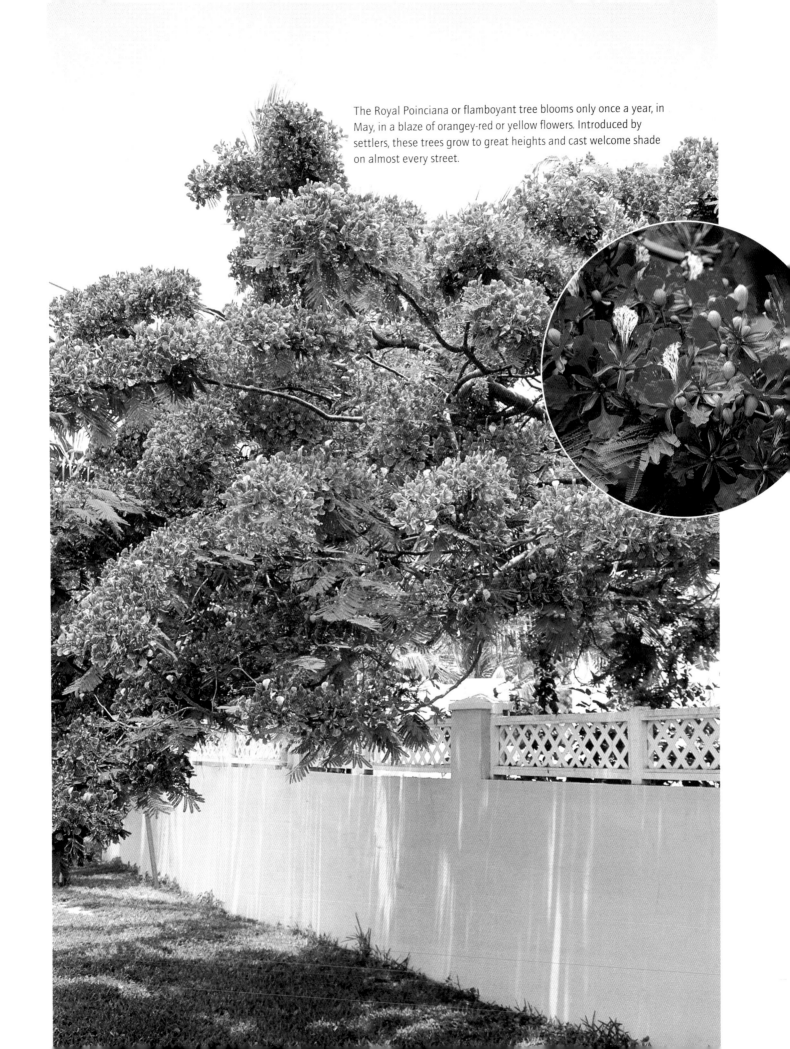

The Royal Poinciana or flamboyant tree blooms only once a year, in May, in a blaze of orangey-red or yellow flowers. Introduced by settlers, these trees grow to great heights and cast welcome shade on almost every street.

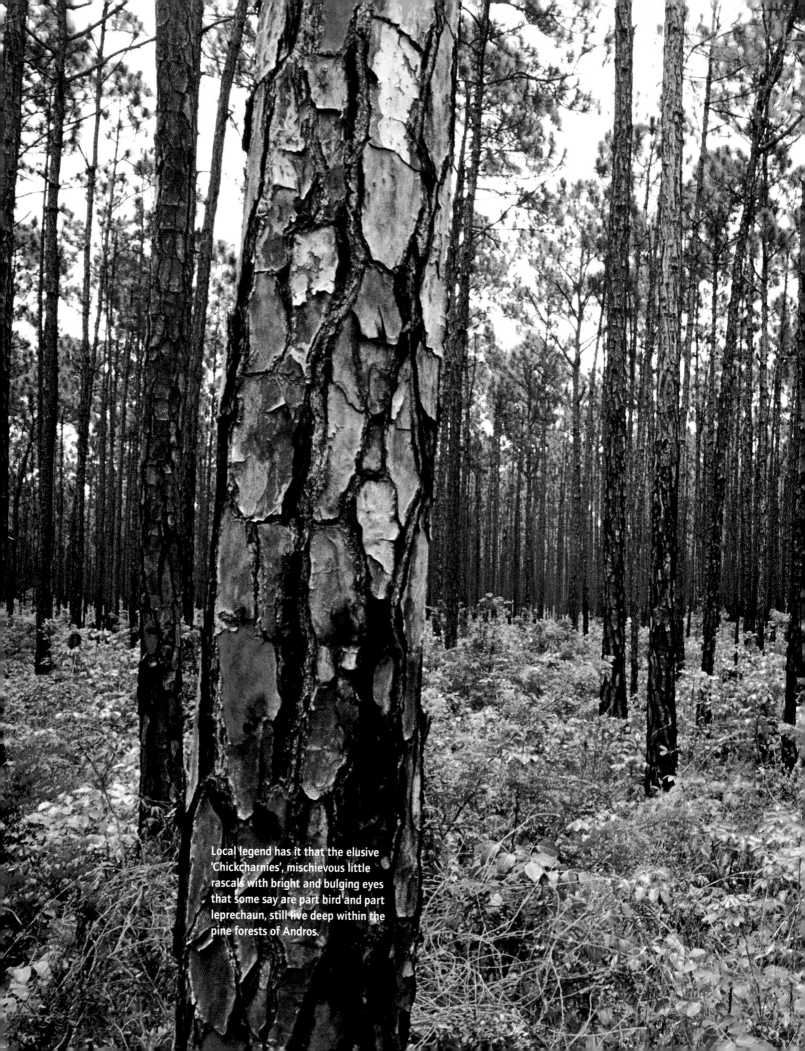

Local legend has it that the elusive 'Chickcharnies', mischievous little rascals with bright and bulging eyes that some say are part bird and part leprechaun, still live deep within the pine forests of Andros.

Yellow Elder is the national flower of The Bahamas.

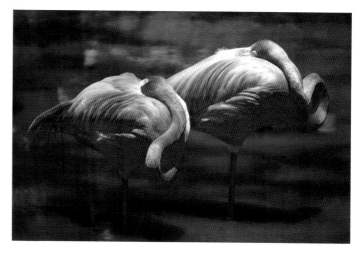

Inagua National Park, situated on the island of Great Inagua, boasts the largest breeding colony of West Indian flamingos in the world. Maintained by the Bahamas National Trust, other threatened species such as the Bahamian Parrot are also found there.

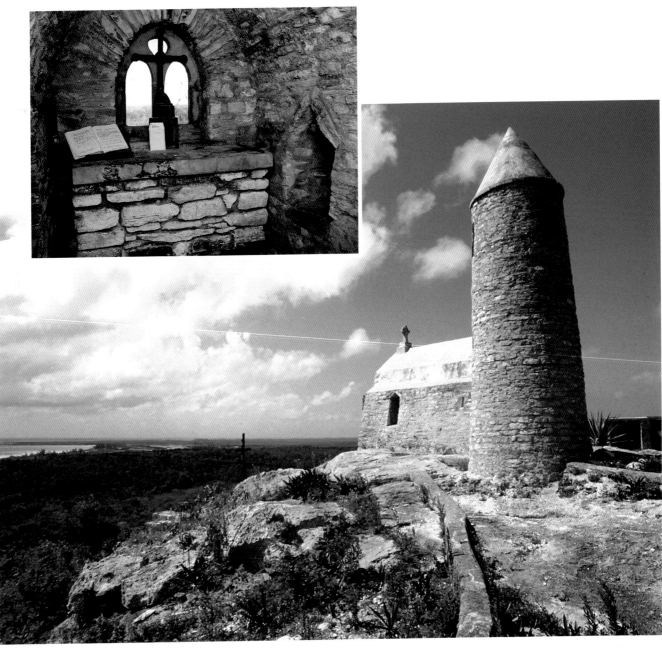

The highest point in The Bahamas is Mount Alvernia on Cat Island, at an elevation of 206 feet above sea level. On its peak stands a miniature monastery built in the 1940s by Father Jerome, an architect and Jesuit missionary. He built several churches throughout the islands and his tomb is also located on Mount Alvernia.

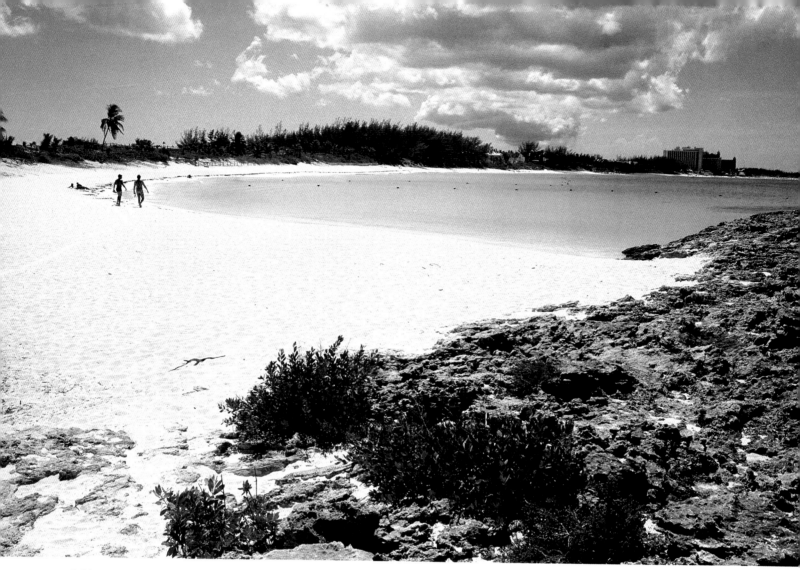

Cabbage Beach on Paradise Island is one of the most beautiful strands in the Caribbean region.

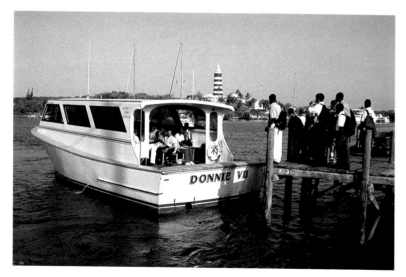

Off to school in Hope Town.

Opposite page (bottom)
The Glass Window Bridge on North Eleuthera, built to replace a natural rock formation, offers a spectacular vista between the deep blue Atlantic Ocean and the shallow waters of the Bahama Banks. Battered by hurricanes which threaten the islands between June and November, the bridge is constantly under repair and the government is now considering alternative means of crossing the 'window'.

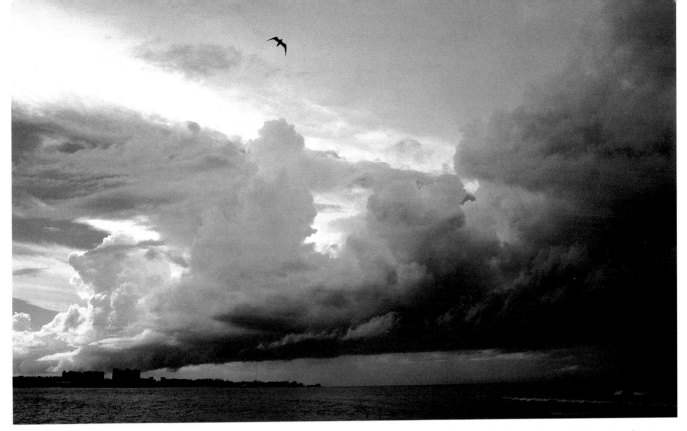

It is not uncommon in the winter months for the North American cold fronts to reach as far south as The Bahamas. Here a fast moving front bears down on New Providence sending temperatures into the upper 50s.

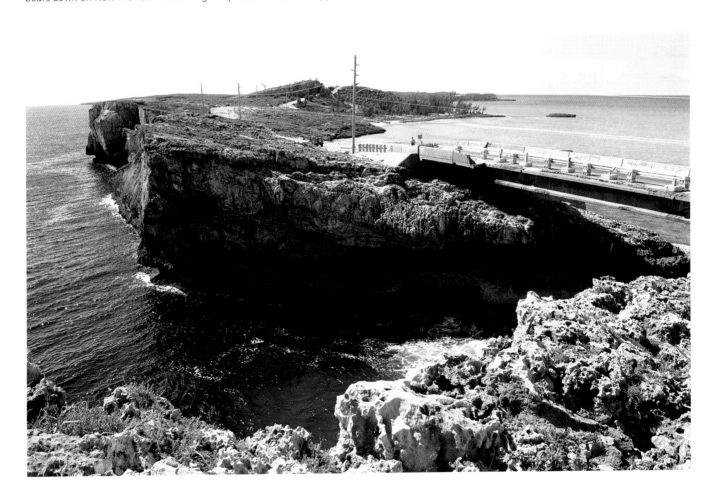

Nassau Notes

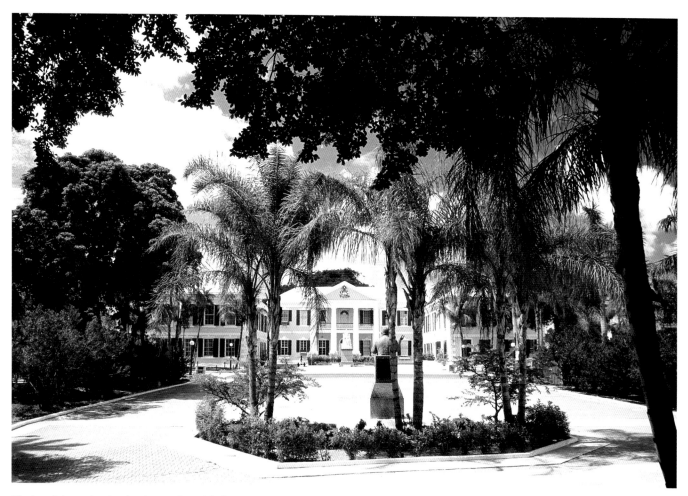

The loyalists made a lasting impression with the tremendous growth in Nassau's social and physical structure. New roads and buildings were built, new churches and schools encouraged education, and the overall standard of living was raised. The public buildings in Rawson Square, built in the early 1800s, were fashioned after the Governor's Mansion in North Carolina and are a lasting tribute to loyalist influence.

Opposite page
Bank Lane and the Court House.

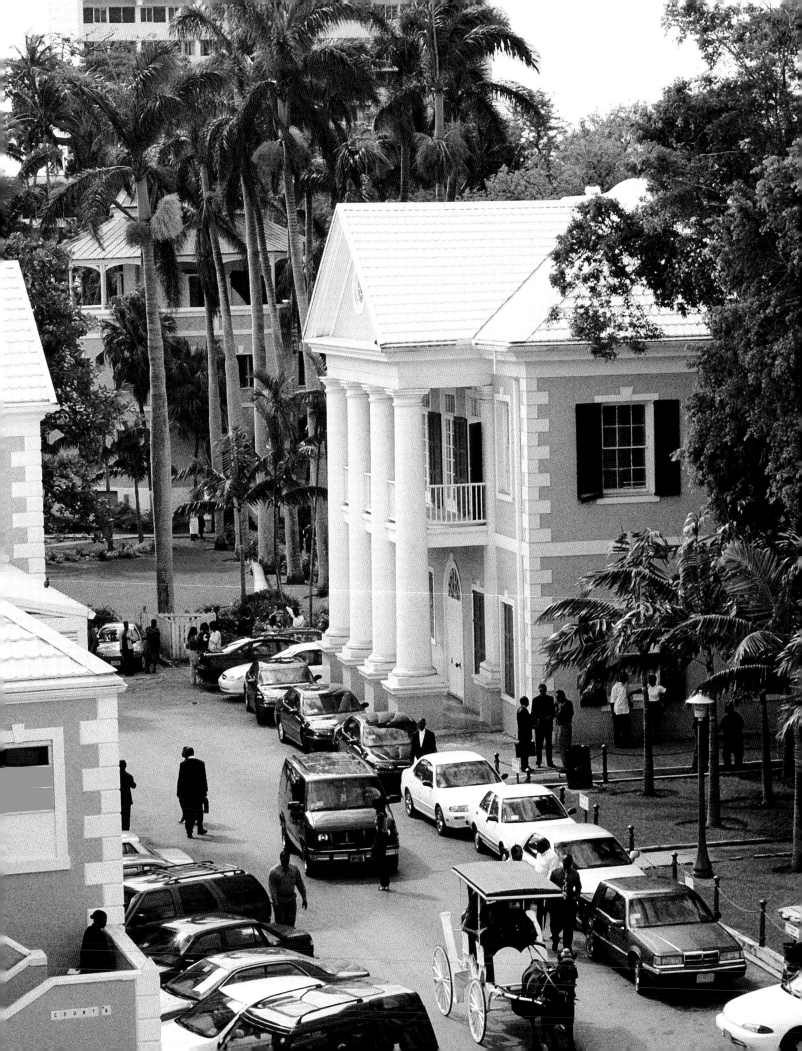

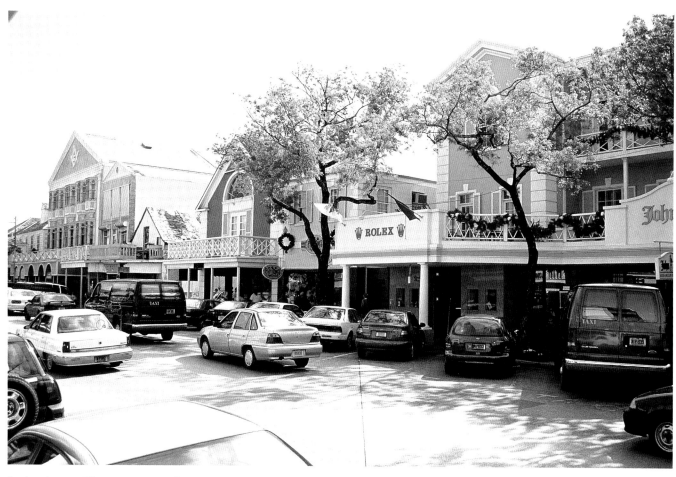

During the past 50 years Bay Street has seen a few changes but the overall character and charm have remained the same.

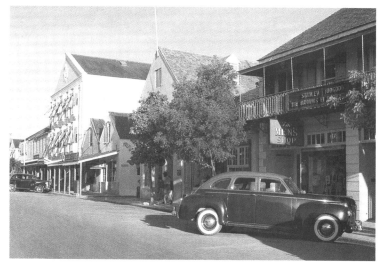

Stan Toogood's green Plymouth parked in front of the first Toogood's Photography.

Waiting for the bus to the Mall.

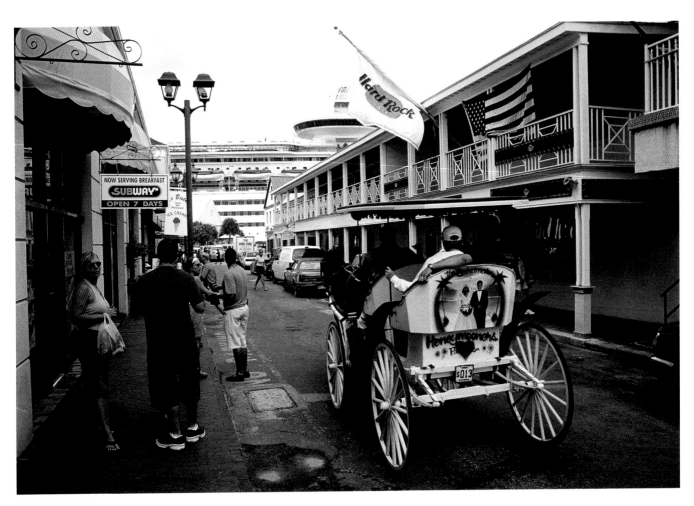

Charlotte Street, downtown Nassau.

Staying out of the summer sun.

The Queens Staircase leading to
Fort Fincastle was named in
honour of Queen Victoria. The
steps, 'dem sixty sev'n goin' up, and
dem sixty six goin' down' as the
local guides like to point out, were
carved out of solid rock.

A walk through the Botanical Gardens in Nassau.

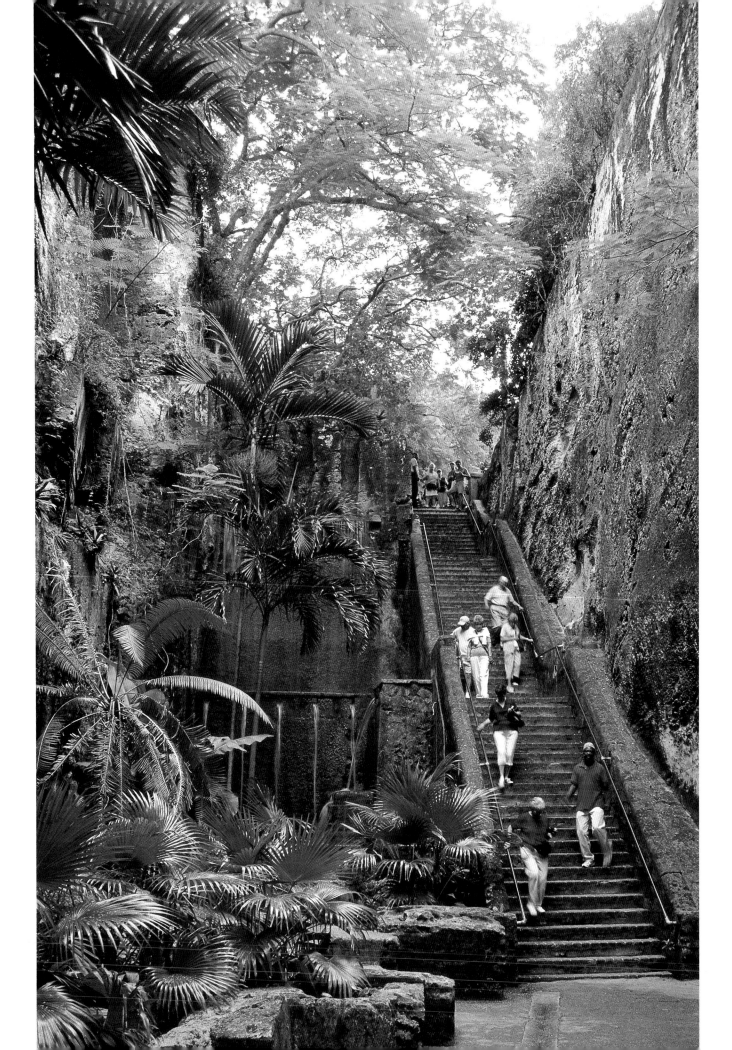

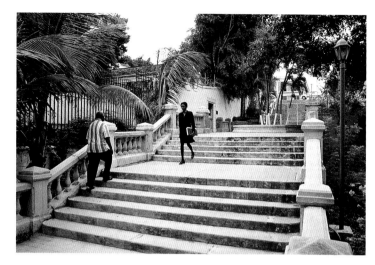
Frederick Street Steps in Nassau.

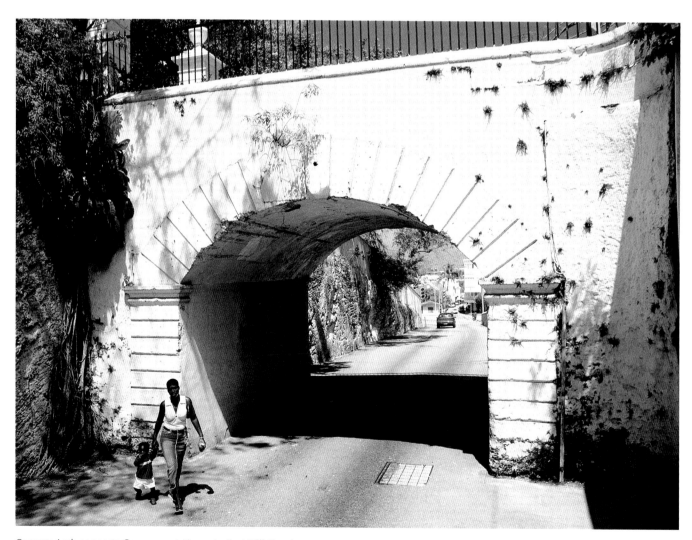
Gregory Arch connects Government House to East Hill Street.

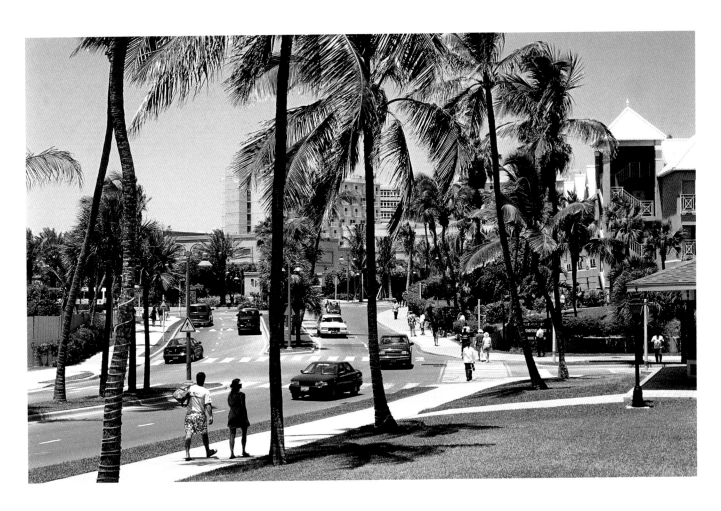

Single lane on Sears Road and multi-lane on Paradise Island.

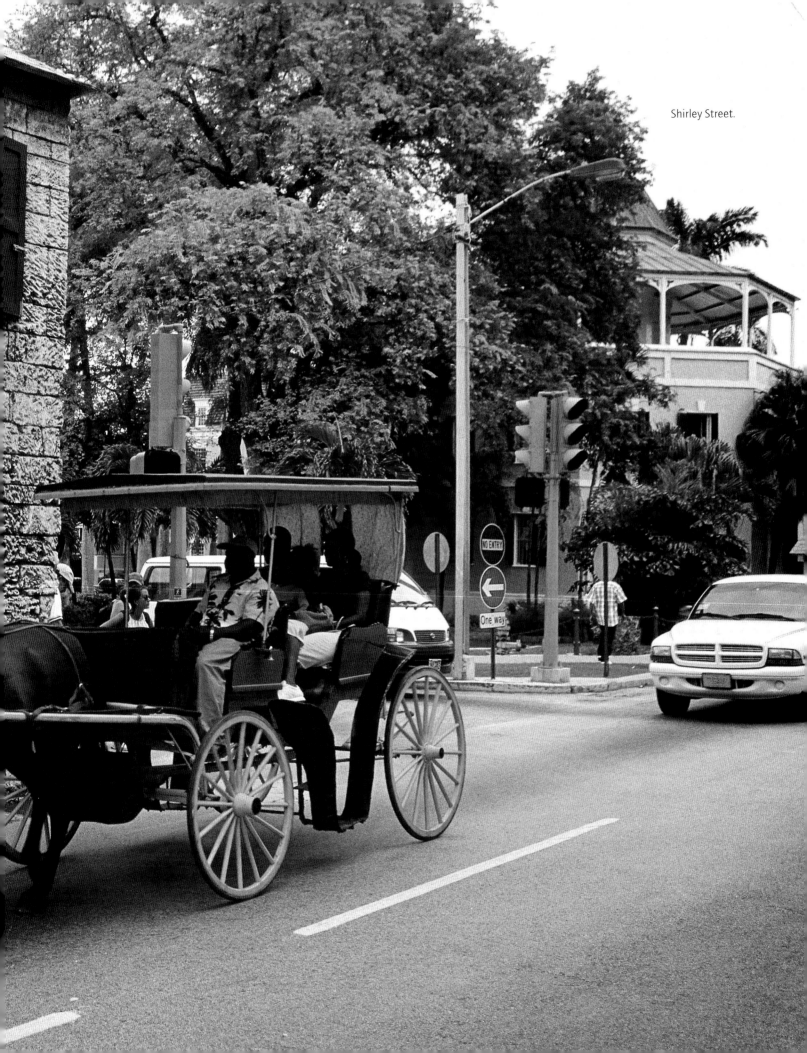

Shirley Street.

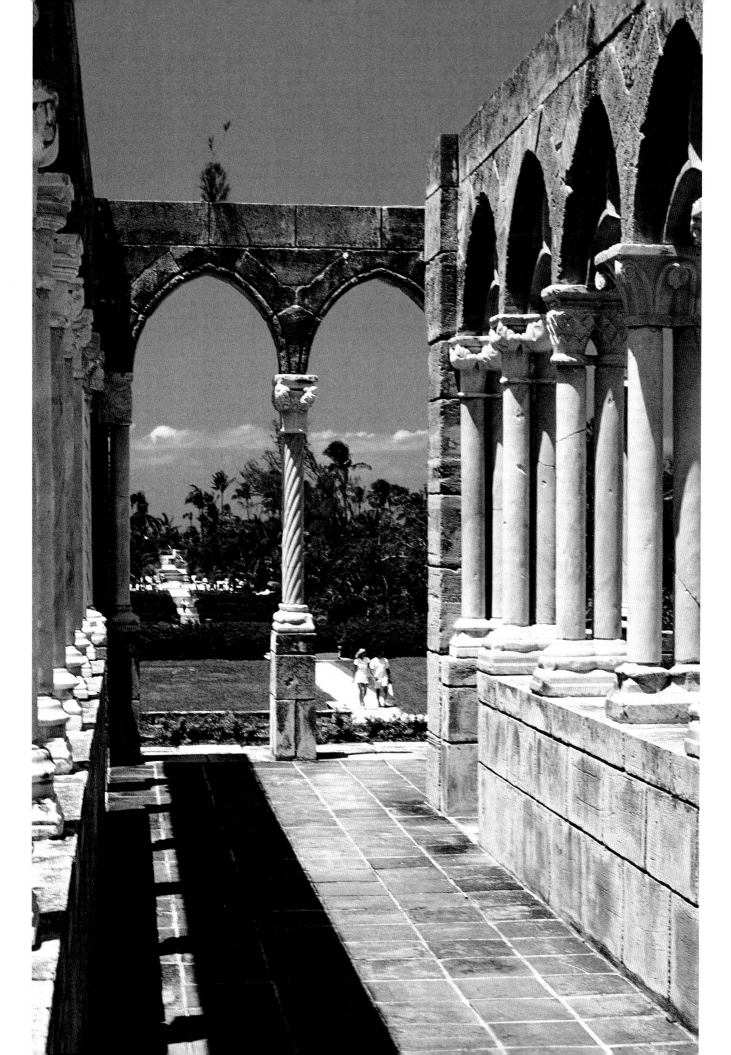

Look, but please don't touch! A car show at the Arawak Cay heritage site.

Opposite page

The Cloister on Paradise Island was imported to The Bahamas from France and reconstructed near the Ocean Club by Huntington Hartford, the island's former owner.

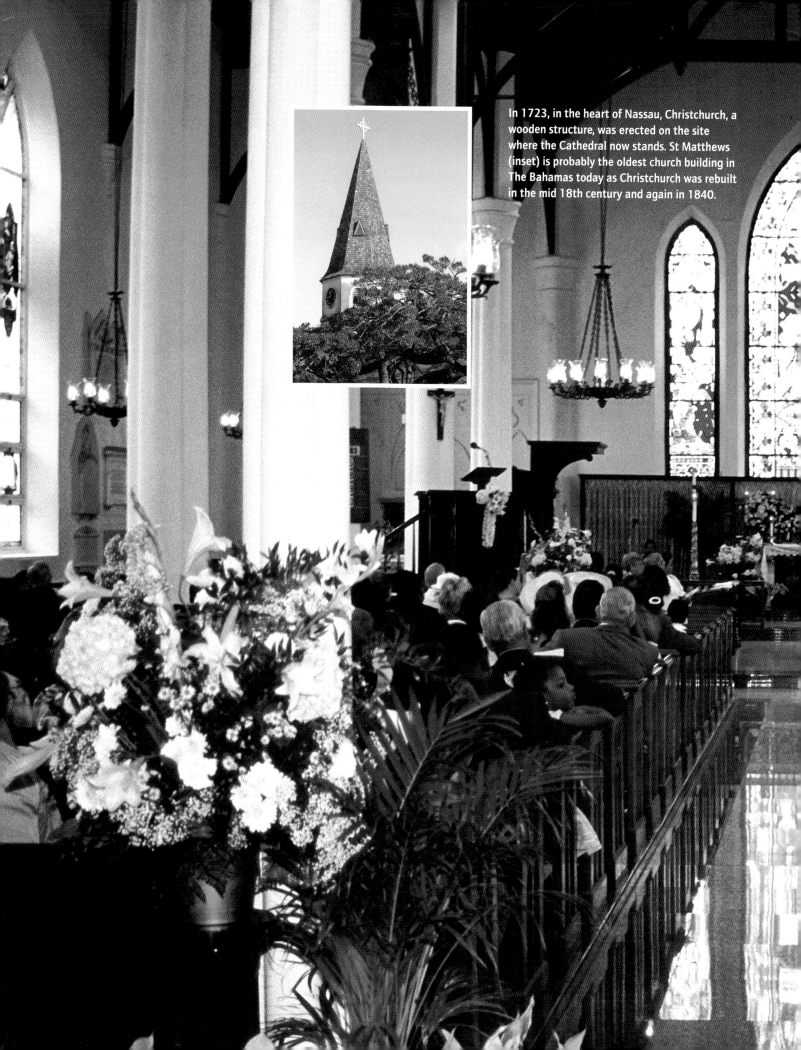

In 1723, in the heart of Nassau, Christchurch, a wooden structure, was erected on the site where the Cathedral now stands. St Matthews (inset) is probably the oldest church building in The Bahamas today as Christchurch was rebuilt in the mid 18th century and again in 1840.

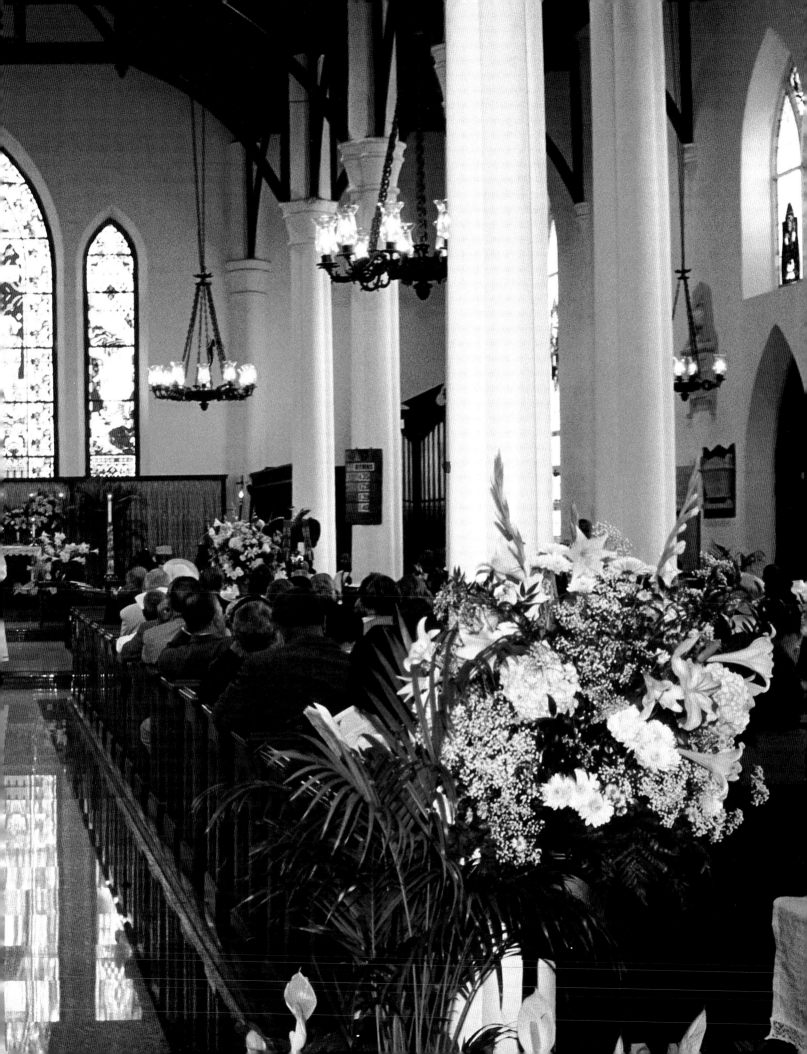

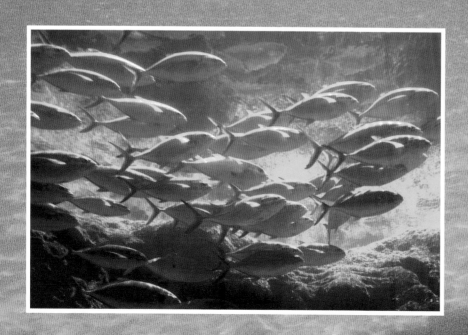

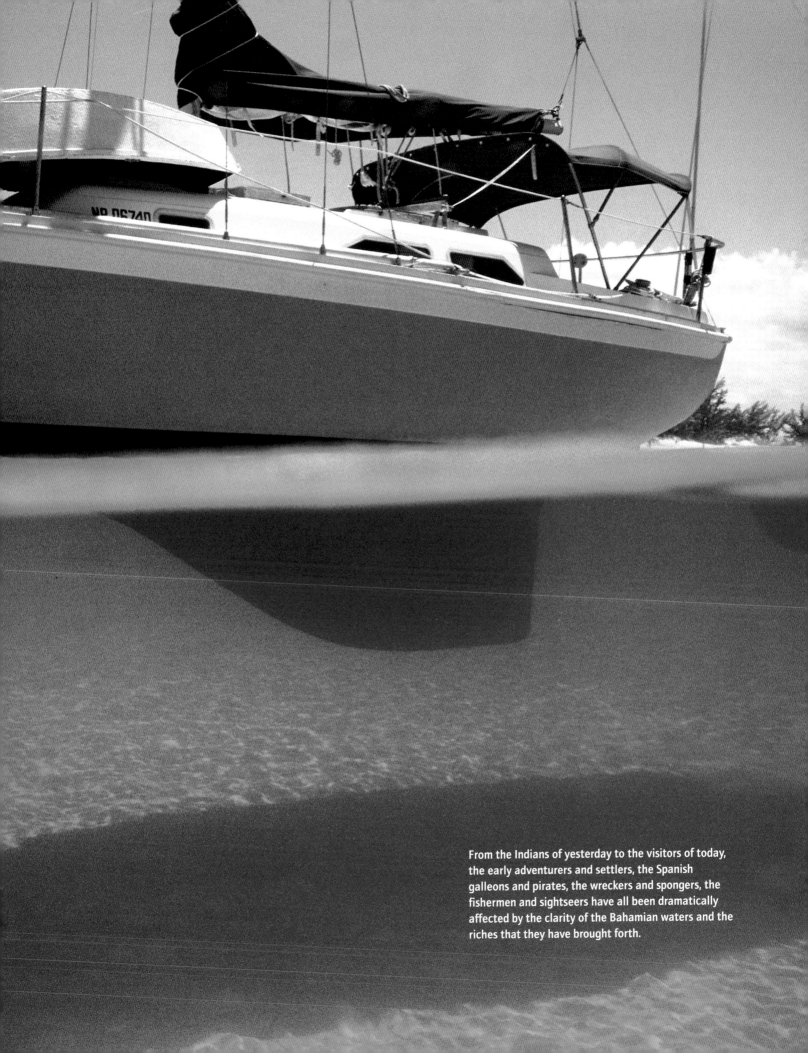

From the Indians of yesterday to the visitors of today, the early adventurers and settlers, the Spanish galleons and pirates, the wreckers and spongers, the fishermen and sightseers have all been dramatically affected by the clarity of the Bahamian waters and the riches that they have brought forth.

Like ripples in a tidal pool, this young nation continues to grow into its own unique and independent character. The vigour and force of a united people are represented by the strong colour of the black on the flag. The gold and aquamarine represent the rich resources of the land and sea. These are precious gifts that all Bahamians treasure and at the same time share unselfishly with all those who wish to behold the beauty of this Bahamaland.

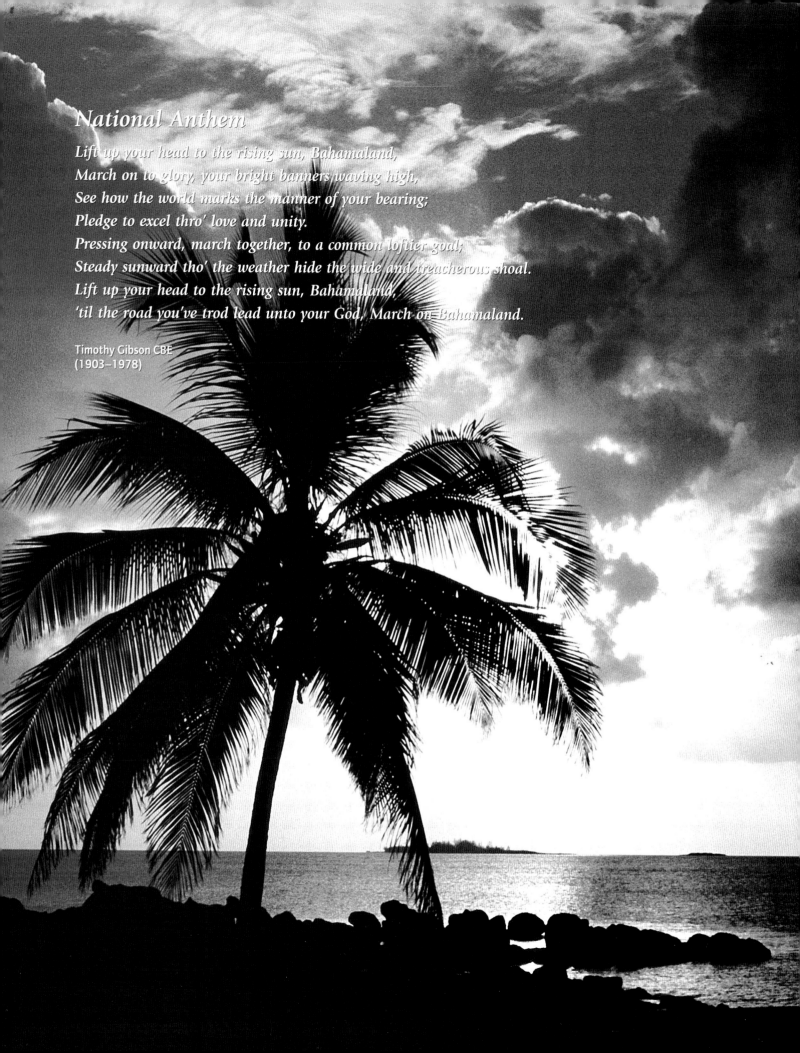

National Anthem

Lift up your head to the rising sun, Bahamaland,
March on to glory, your bright banners waving high,
See how the world marks the manner of your bearing;
Pledge to excel thro' love and unity.
Pressing onward, march together, to a common loftier goal;
Steady sunward tho' the weather hide the wide and treacherous shoal.
Lift up your head to the rising sun, Bahamaland,
'til the road you've trod lead unto your God, March on Bahamaland.

Timothy Gibson CBE
(1903–1978)